IMAGES
of America

FAIRPORT
HARBOR

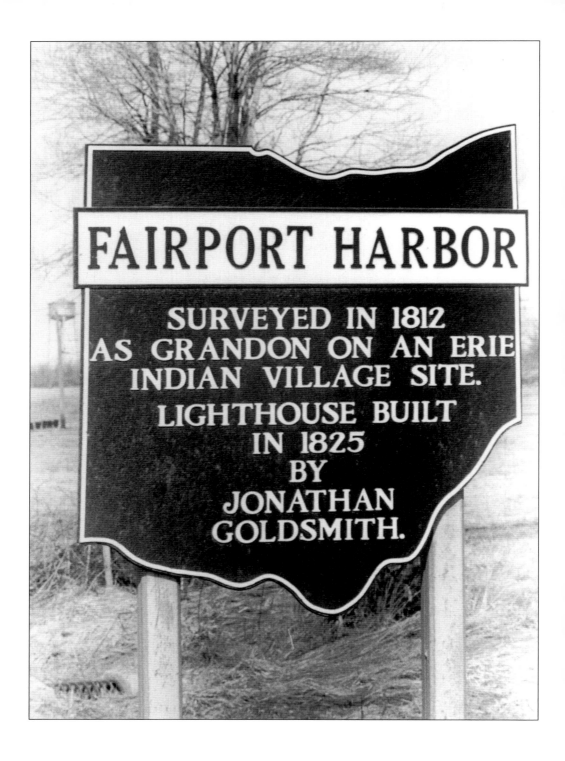

FAIRPORT HARBOR

SURVEYED IN 1812
AS GRANDON ON AN ERIE
INDIAN VILLAGE SITE.

LIGHTHOUSE BUILT
IN 1825
BY
JONATHAN
GOLDSMITH.

IMAGES

of America

FAIRPORT
HARBOR

Fairport Harbor Historical Society

ARCADIA

First Printed 2003.
Reprinted 2003.

Published by Arcadia Publishing,
an imprint of Tempus Publishing, Inc.
Charleston SC, Chicago, Portsmouth NH,
San Francisco

Printed in Great Britain.

Library of Congress Catalog Card Number: 2002094832

For all general information contact Arcadia Publishing at:
Telephone 843-853-2070
Fax 843-853-0044
E-Mail sales@arcadiapublishing.com

For customer service and orders:
Toll-Free 1-888-313-2665

Visit us on the internet at http://www.arcadiapublishing.com

CONTENTS

ACKNOWLEDGMENTS

The Fairport Harbor Historical Society Book Committee gratefully thanks all of those who donated the photos we have in our library. We also thank those who loaned their early photos to complete the book. Carol Bertone scanned the hundreds of pictures and articles. Because of the mandatory limited space, the decision of what we should include was difficult. We hope this edition meets the approval of our interested readers.

Helen Kasari, Julia Lehto
Louise Nagy, Eleanore Sabo

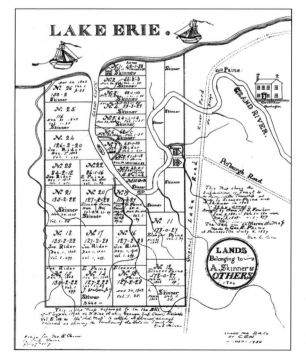

This 1806 map of Grandon pictures lands owned by Abraham Skinner. Mr. Skinner laid out the town plat of Grandon (Fairport) in 1812.

INTRODUCTION

Fairport Harbor is located on the shore of Lake Erie about 30 miles east of Cleveland. The Grand River, which flows around the town and empties into the lake, makes the town almost an island. Two bridges and one road over land give access to neighboring communities.

Fairport Harbor, Ohio, was first named Grandon, although certain early papers already referred to it as Fairport. The land was a part of the Connecticut Western Reserve and belonged to the Connecticut Land Company. They sent a group of surveyors here in 1796 and 1797, after which the land was sold to certain men, mostly from the New England states.

Fairport became a village and elected its own mayor and town council in 1836. Before that, residents had been under the supervision of Painesville Township. After the railroads were built in the 1850s and began to transport goods by rail, lake traffic began to slow down and, as a consequence, many people left Fairport. At this time Fairport again became a part of the Painesville Township government. In 1889 a mayor and council members were again elected, and this form of government has lasted until the present day.

The first lighthouse and keeper's dwelling were built in 1825 by the famous architect Jonathan Goldsmith. The two-foot foundation was rebuilt due to settling conditions 10 years later. At first, 13 oil lamps were used for light in the tower. Later, the U.S. Lighthouse Service decided that a Fresnel lens should be used in all U.S. lighthouses, as they were such an improvement over the old lights. Fairport received a third-order Fresnel lens in 1858. This lens was moved into the new tower, built in 1871, and used there until 1925. A new keeper's dwelling was also built in 1871, and now serves as the Fairport Marine Museum. The third-order lens can be seen on display at the museum. A new lighthouse, a combination light and foghorn station, was completed on the west breakwater in 1925. It has been completely automated since 1948, so the U.S. Coast Guard no longer has the responsibility of staying in the upstairs quarters of the lighthouse. The U.S. Coast Guard's main duties now consist of search and rescue missions, as well as keeping a watchful eye on our shoreline and river traffic.

At first, most of Fairport Harbor's residents were of English and Irish descent, but when the ore docks were built, Fairport received a great many Finnish, Hungarian, and Slovak immigrants. These groups organized their churches and halls. These halls—the Temperance Hall and Plum Street Hall—built in the late 19th century, were used for programs, recreation, athletics, and dancing. They had dining rooms for single men who had emigrated from foreign countries to work here. The cooks also packed their lunches for them.

All of Fairport's churches are situated in an area between Eagle and Plum Streets running

from Third Street to New Street. The first church to be established was the Congregational Church, where services were conducted in the English language. In the other churches, namely Lutheran, Reformed, Byzantine Rite, and Roman Catholic services were held only in the immigrants' foreign languages. Eventually, English services and Sunday schools were introduced in the early 1940s, although foreign language services with dwindling attendance continue to the present day (2002). Ecumenical services, which offer residents a sense of community, are held at various churches. This small village of 3,100-plus people with different cultures and religious beliefs exemplifies a true melting pot.

The first school was organized and built in 1845 next to the First Congregational Church. In 1876 a brick building was built, a structure presently occupied by the fire department. Later, due to overcrowded conditions, the school board had to have some classes conducted in houses and the upstairs of store buildings until a new building was constructed in 1902. Unfortunately, this building burned down on February 10, 1910. Temporary schoolrooms were rented in various buildings until the new school building was ready in January 1912. A high school building was erected and ready for use in September 1921.

In the spring of 1924, by resolution of the board of education, the names of three Ohio presidents were given to the three school buildings. The Third Street School became Garfield School; Plum Street School became McKinley; and the high school became Harding High School.

A business directory printed on an 1874 map of Fairport lists mostly wholesale and retail dealers of fresh fish of all kinds. Only one ship's carpenter is advertised, so one can see that fishing was the main means of livelihood at that time.

Small businesses served the needs of the people for many years until large malls and discount stores were built in the county. Before people owned cars, they had many items delivered to their homes. Two dairies brought milk to the porch. Coal dealers shoveled coal down a chute right through the basement window into the coal bin. "Banana Joe" and others drove their trucks up and down the streets to sell fruits and vegetables. Some of the grocery stores sent men to take orders in the morning right from the ladies' kitchens and delivered them later in the day. All of their needs, such as clothing, food, and hardware, could be met within walking distance. Fairport had its own movie theater, and later, when more families had cars, the village also had several gas stations and garages. Several doctors and dentists had practices in Fairport. Families traveled to Painesville and Cleveland to do additional shopping by streetcar, bus, and eventually the family car. Many also took the New York Central or Nickel Plate Railroad to the Terminal Tower in Cleveland.

When the ore docks were established, ship traffic increased considerably as the large freighters brought in loads of iron ore from the iron ore mines in Michigan and Minnesota. Here, the ore was transferred from the ship's holds to railroad cars or onto large piles on the docks. The ore was transported to Youngstown, Ohio, Pittsburgh, Pennsylvania, and other steel mills in the vicinity. The docks were the main employers in the town until the advent of a major industry—The Diamond Alkali Company—which was established in Fairport in 1912 to produce soda ash, caustic soda, and bicarbonate of soda. The plant employed several thousand people in Fairport and its vicinity. Fairport schools benefited from their taxes. When the plant closed on December 31, 1976, due to obsolescence, the Fairport residents found it necessary to pass a 20-mill levy in order to keep funding their schools and remain an Exempted Village School District.

As one looks at the pictures and captions in this book, one will see the progression of time in the village from the early 1800s to the present.

As preparations begin for the Ohio Bicentennial in March of 2003 (Ohio became a state in 1803 after having been a part of the Northwest Territory), one discovers that Fairport's history closely parallels Ohio's statehood, as the first pioneers settled here in 1803.

One
LIGHTHOUSES

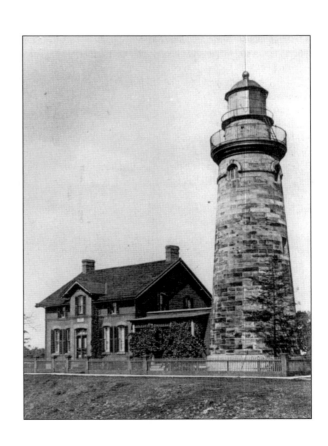

The vine-covered passageway between the lightkeeper's dwelling and tower is original to the 1871 tower.

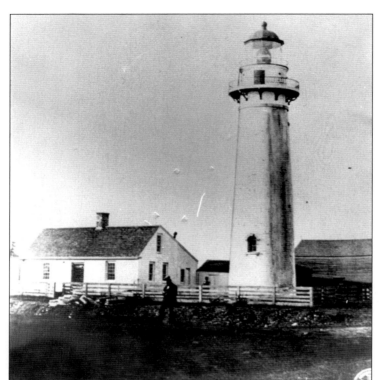

The original brick lighthouse and keeper's dwelling was built by Jonathan Goldsmith in 1825. The iron lantern on top of tower was in the shape of an octagon.

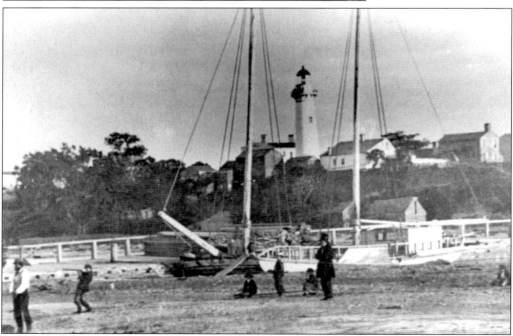

This 1858 photo shows a sailing vessel's masts framing the 1825 lighthouse. It is thought to be a shipbuilding yard. Notice the man in the center of the photo wearing a "stovepipe" hat and a boy on the left holding a rifle.

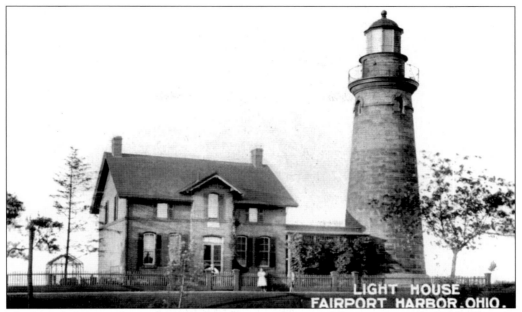

The U.S. lighthouse keeper's dwelling and tower is pictured here in the early 1900s. Captain Joseph Babcock, lightkeeper, is sitting on the front steps.

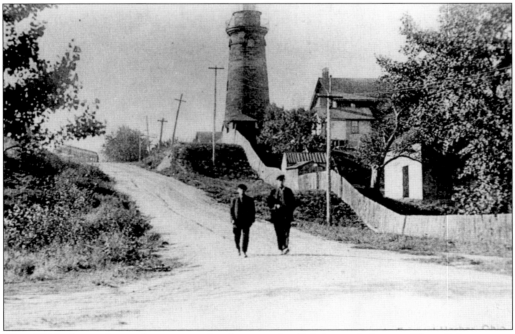

This 1912 photo shows the summer kitchen on the lightkeeper's house. The oil house was added in 1904. Notice the streetcar rounding the corner.

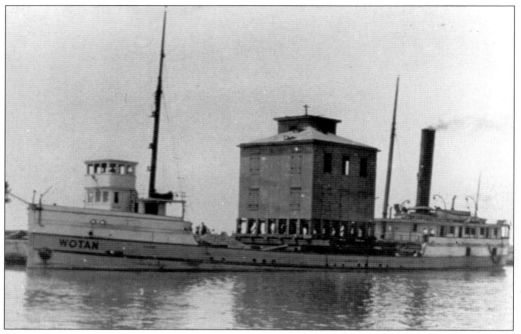

The steamer *Wotan* arrives in Fairport from Buffalo with a lighthouse shell structure at 1:45 p.m., June 21, 1921.

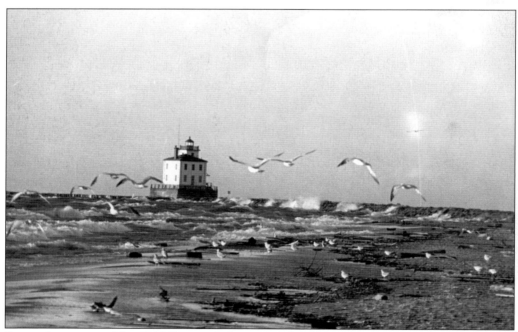

Pictured is a view of the 1925 Fairport light on west breakwater.

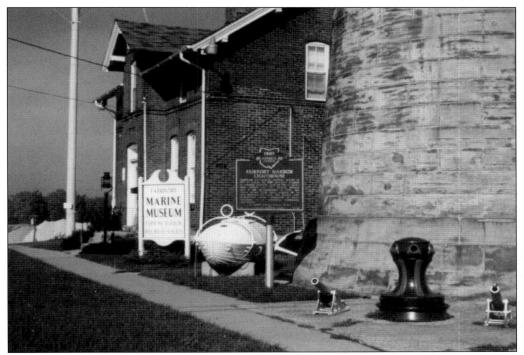

Welcome to the lighthouse museum and tower entrance! The life car is one of three known to be in existence.

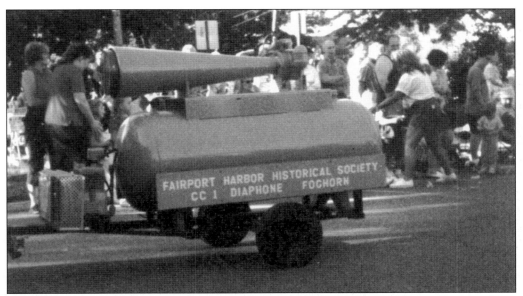

This CC1 diaphone foghorn was located on the first floor of the West Breakwater Light and was in service until 1965, when it was replaced with a modern sound signal. Characteristic of CC1 diaphone: 1 second blast, 1 second silent; 1 second blast, 3 seconds silent; 1 second blast, 23 seconds silent. The foghorn was restored in 1998 and is now mounted on a compressed air tank and attached to a 2-wheeled trailer. It is a prized possession of the Fairport Marine Museum.

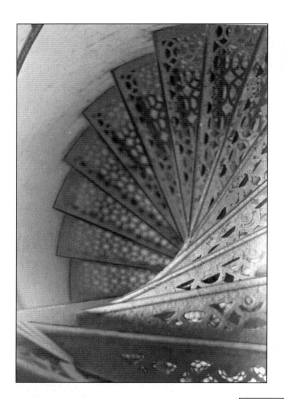

Here is pictured the original stairway leading to the lens deck of the Fairport light tower.

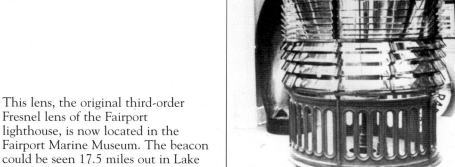

This lens, the original third-order Fresnel lens of the Fairport lighthouse, is now located in the Fairport Marine Museum. The beacon could be seen 17.5 miles out in Lake Erie.

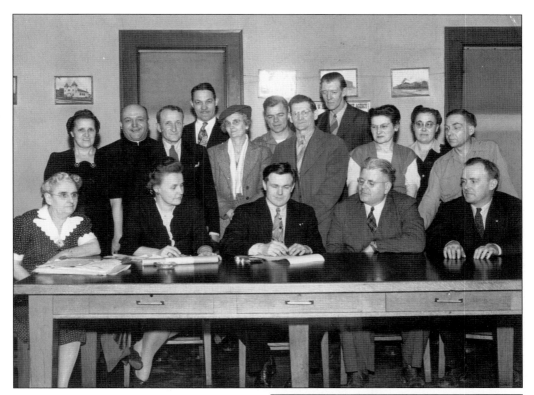

Fairport Harbor Historical Society was organized March 2, 1945; incorporated March 17, 1945; and its constitution adopted March 23, 1945. Society members are pictured, from left to right, as follows: (front row) Irene Radike, treasurer; Lillian Robinson, secretary; George Gedeon, president; Elijah Brown, and second vice president; Eero Liimakka; (middle row) Mrs. Andrew Haynes; Andrew Haynes; Pearl Cadwell; Andrew Kraynik; Frieda Winchell; Maynard Hungerford; (back row) Fr. D. Hoffman, trustee; John Laczko, trustee; James Galm; Carroll Mitchell, trustee; and Mrs. Zapp.

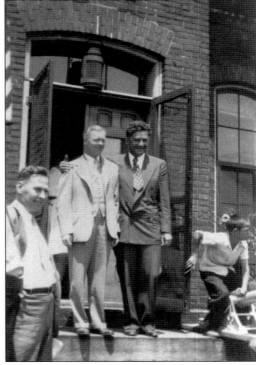

The Marine Museum was dedicated during the Fairport Mardi Gras Celebration on July 4, 1946. Pictured from left to right are Saul Olin, Mayor Art Ritari, and Ohio Governor Frank J. Lausche.

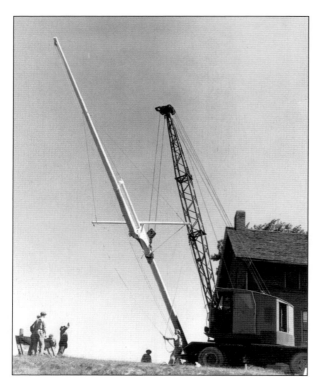

The mast of the U.S.S. *Michigan* (*Wolverine*) is placed on the grounds of the museum. The *Michigan* was the first iron warship of the U.S. Navy. It was dedicated in June 1950, during the Fairport Mardi Gras.

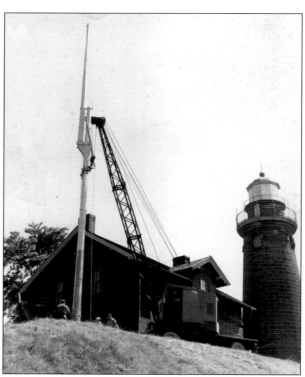

Pictured here is the raising of the flagpole mast of the U.S.S. *Michigan* (*Wolverine*).

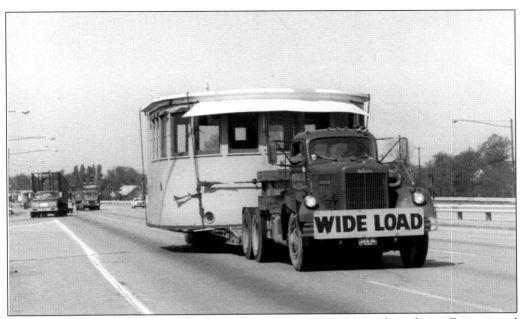

The pilot house, en route from the Str. Frontenac on Rt. 90, was brought to Fairport and attached to the museum on May 16, 1967.

The mast had to be taken down before the pilot house could be placed into position on May 17, 1967.

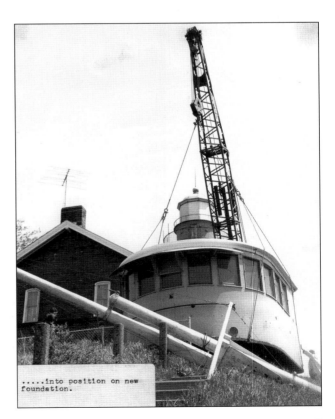

.....into position on new foundation.

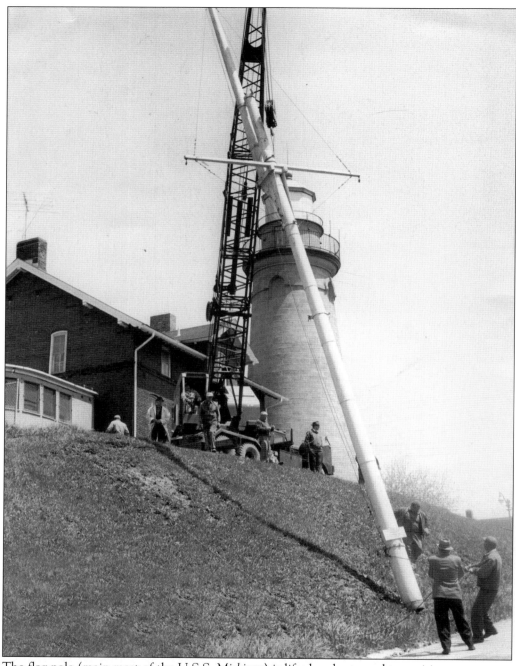

The flag pole (main mast of the U.S.S. *Michigan*) is lifted and returned to position.

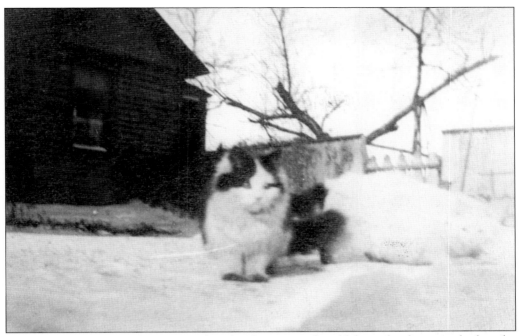

These two cats belonged to Mary Babcock. Please note the old frame kitchen attached to the north side of the lighthouse dwelling.

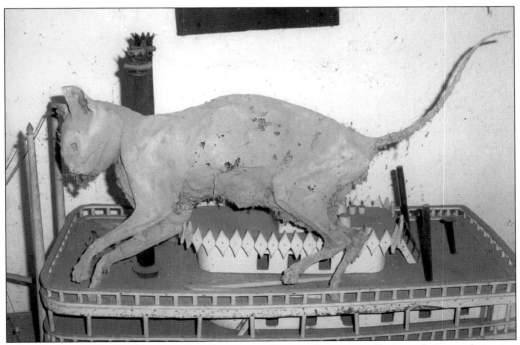

In 2000 this mummified cat was found in a crawl space during installation of air conditioning ductwork in the museum. Could this be one of Mary Babcock's cats? Could it be the "ghost cat" that was seen many times by a former curator?

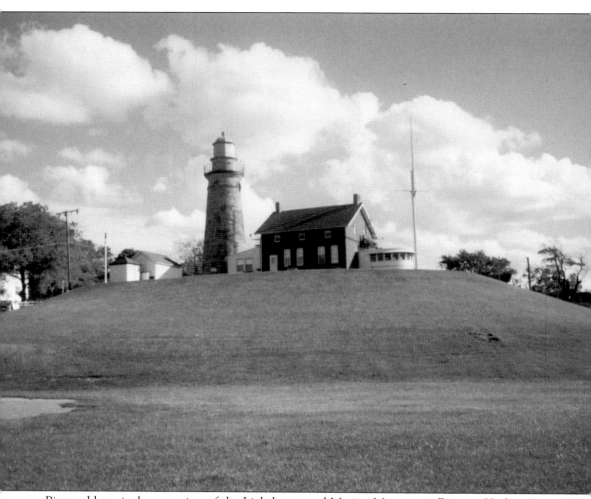

Pictured here is the rear view of the Lighthouse and Marine Museum in Fairport Harbor.

Two
DOCKS AND SHIPPING

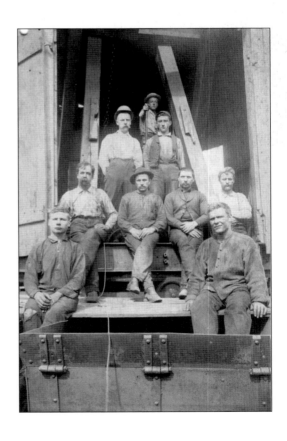

Ore dock workers are pictured here in this
1893 photograph.

Here is a view of the P&LE ore dock office on "Walnut Hill."

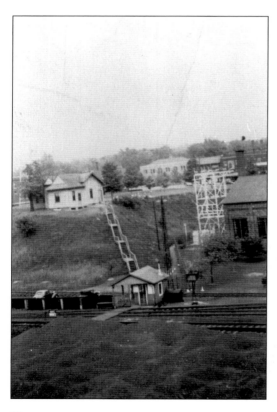

The employee entrance to P&LE dock is in the foreground and the office is at the top of the stairs. To the far left is the Lawrence building; across the street is McCrone's, the A&P, Colgrove's, and Neal Printing.

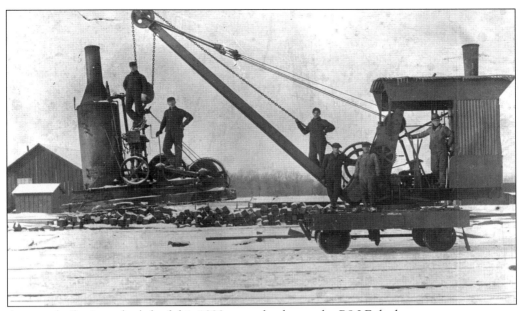

A steam boiler is to the left of this 1890 ore unloader on the P&LE dock.

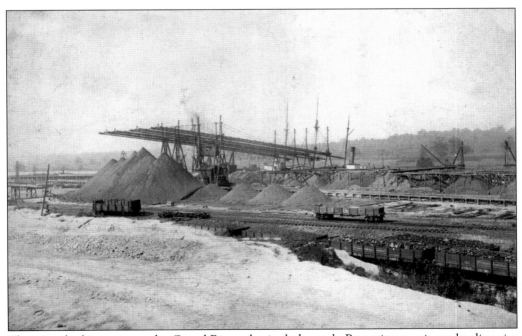

This view looking west to the Grand River also includes early Browning gravity unloading rigs on the P&LE dock.

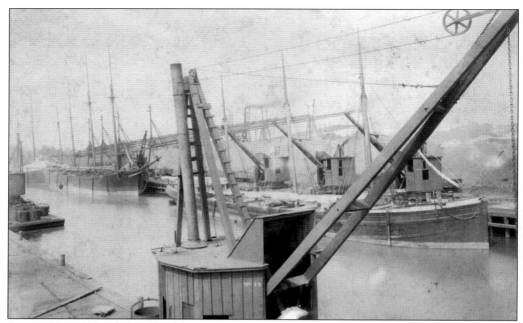

Pictured here is an unloading machine at the P&LE ore dock, c. 1895. A cantilever unloader can be seen in the background.

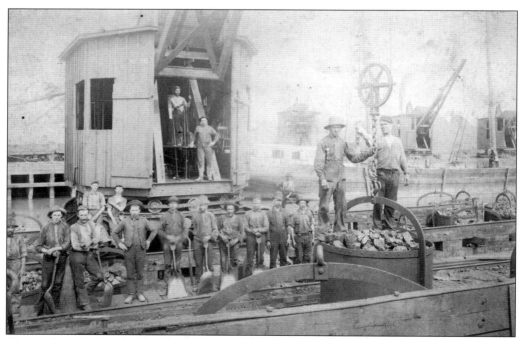

The workers on the ore dock unloading rigs hand-shoveled the ore into buckets, which were then lifted off by crane, c. 1890. It took a week to unload a boat in this manner.

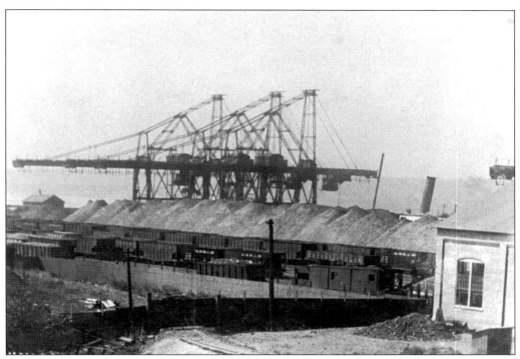

Ore is unloaded at Fairport Harbor.

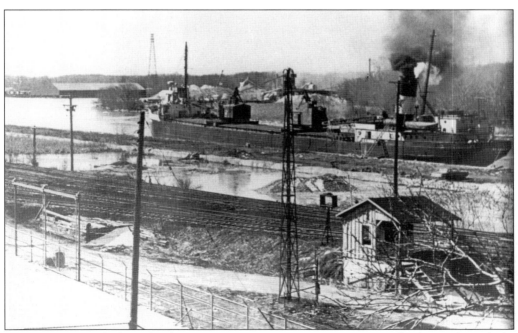

At the P&LE ore dock, Columbia Transportation Company's O.S. *McFarland* crane boat docks in 1962.

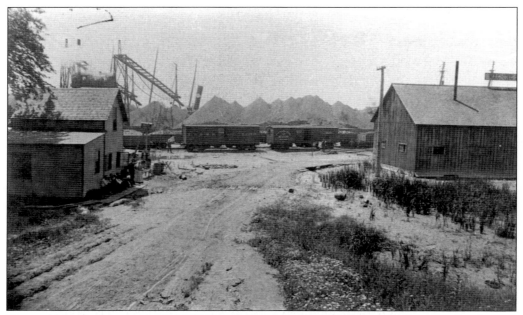

Pictured here is the west end of Old Fourth Street in 1892. Early Brown gravity unloaders are at left. Note ship masts in the background. This area was known as "Finn Hollow" because most of the Finnish people of Fairport lived in this area.

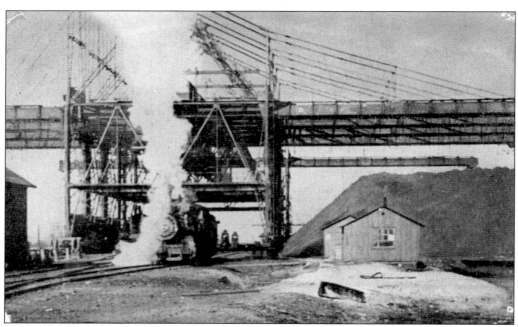

This undated photo shows the Brown hoists at the P&LE dock

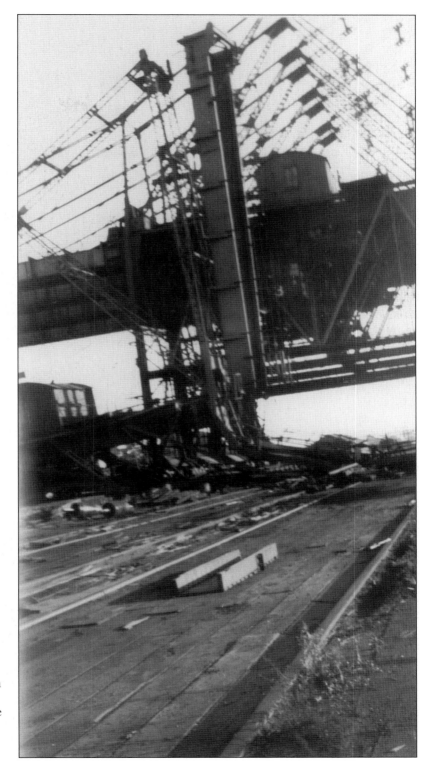

Pictured here is a scene from the demolition of the P&LE ore dock, September 13, 1946.

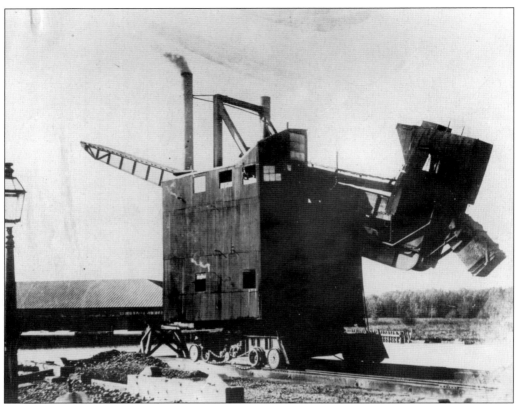

This elevated coal chute, the Bartlett elevator machine, was put into operation in 1892 and was described as one of the finest rigs on the lakes. This machine could dump 500 tons into a vessel every 5 minutes. It once loaded 6 cars of 60,000 lbs. capacity each in 27 minutes. One shovelful held one ton, and it could load a car in less than 10 minutes. It remained in service for 14 years and was replaced by a car dumper. This unloader was known locally as "The Big Finn."

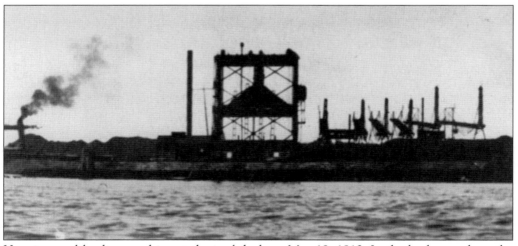

Here is a coal loading machine at the coal dock on May 19, 1912. In the background are the ore unloading rigs at the P&LE dock.

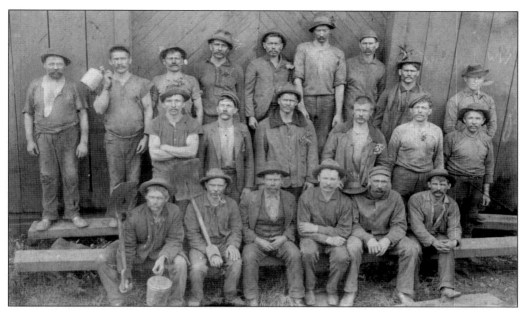

This undated and unidentified photo is of dock workers who unloaded boats with shovels. In 1877 these men earned 7¢ per ton performing this back-breaking work!

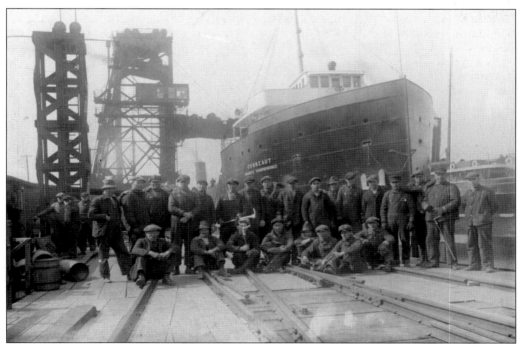

Pictured here is the Toledo, Lorain, and Fairport (TL&F) coal dock, c. 1920. The name "Conneaut" was changed to "Wyandotte" in 1963.

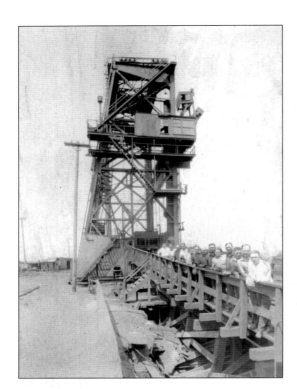

At the end of the 1964 season, the coal dock closed and this coal dumper retired. The facility handled a total of 58,486,361 tons of coal during its lifetime.

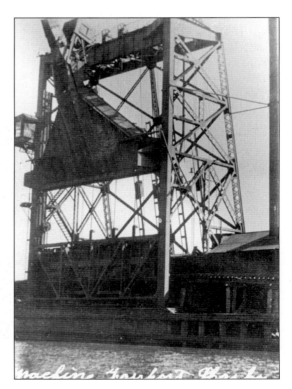

Here is a coal rig at the TL&F coal dock.

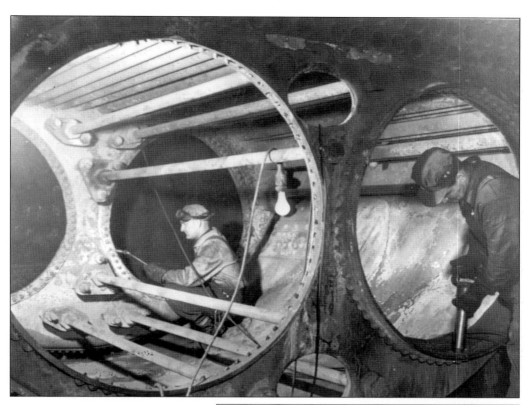

Fairport Machine Shop (a subsidiary of the Columbia Transportation Company) employees William Kozane, left, and R. James Beres, right, make repairs to a ship's boiler. The facility closed at the end of the 1970 season.

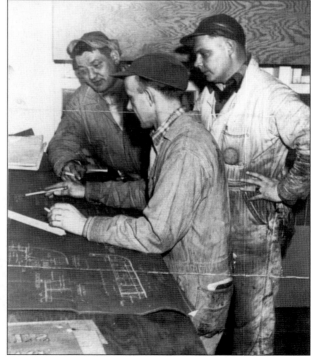

Pictured here, from left to right, are Fairport Machine Shop employees Andrew Kucsma, Donald Lehtinen, and William Seitz.

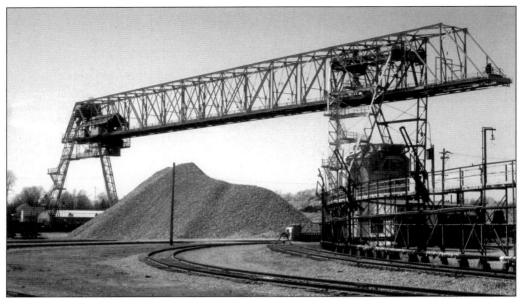

This Diamond Alkali bridge crane was used at the stone dock.

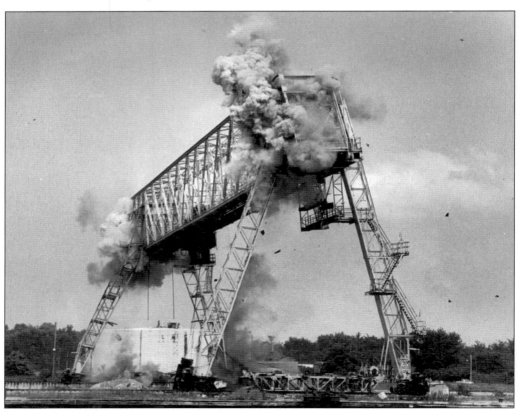

Diamond Alkali ceased operation in 1976. The stone dock bridge crane was demolished in August 1981.

Three
LIFE SAVING SERVICE AND COAST GUARD

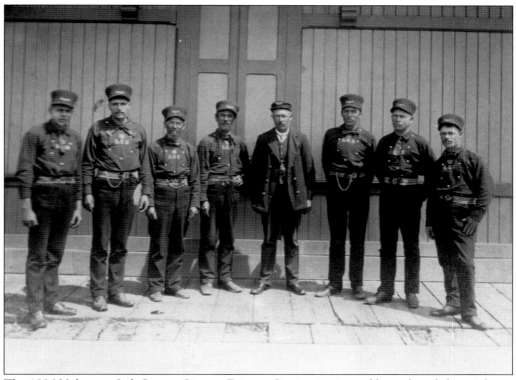

The 1886 Volunteer Life Saving Crew at Fairport Station is pictured here, from left to right, as follows: Knute Joles, James Merrill, Alva Snell, Orin Holley, Capt. George Francis Babcock, John Webster, William Henry, and Mose Duncan.

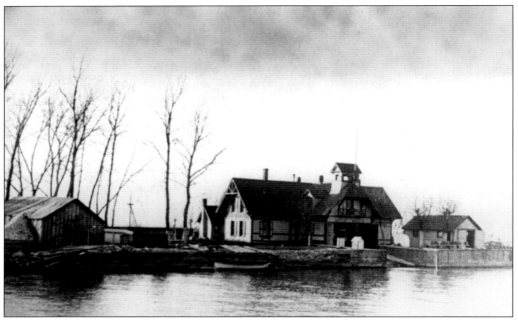

Fairport Life Saving Station, c. 1910, was originally on the Fairport side of Grand River. During the winter of 1878, a building was drawn by horses over the ice-covered river to the west side of the river. Later, on June 28, 1878, Ferris & Garfield moved the rest of the buildings at a cost of $495.

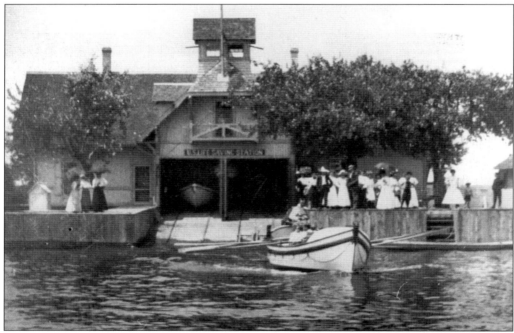

A crew trains at the Fairport Life Saving Station, June 23, 1909. Notice the ladies with their parasols.

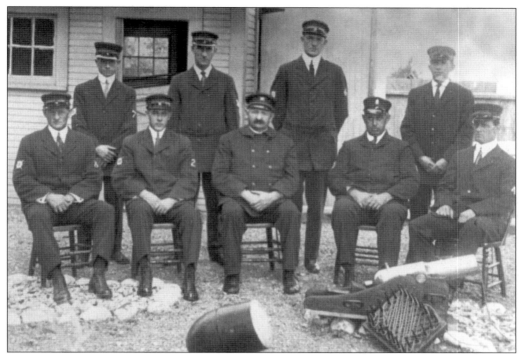

Capt. Rasmussen and the Life Saving Crew pose at the Fairport Station, c. 1910. The Lyle gun and shot line in the foreground is identical to the one displayed in our museum.

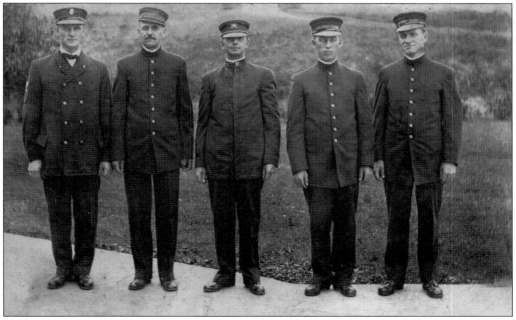

Here is an undated photo of U.S. Coast Guard crew members.

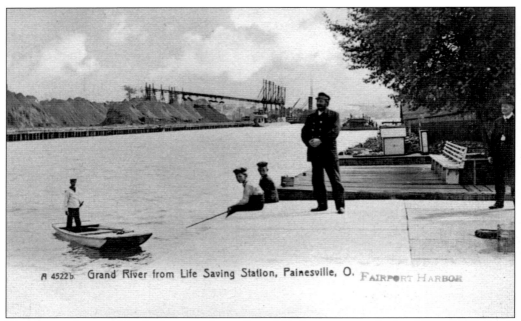

A 4522b Grand River from Life Saving Station, Painesville, O. FAIRPORT HARBOR

This postcard view of the harbor area shows Capt. Nils Rasmussen and school Supt. T.W. Byrns on the right and the Cantilever crane on the left.

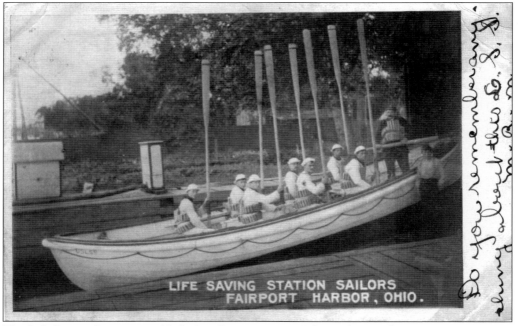

LIFE SAVING STATION SAILORS
FAIRPORT HARBOR, OHIO.

The Life Saving Station, established in Fairport in 1876, hosts these sailors, c. 1900.

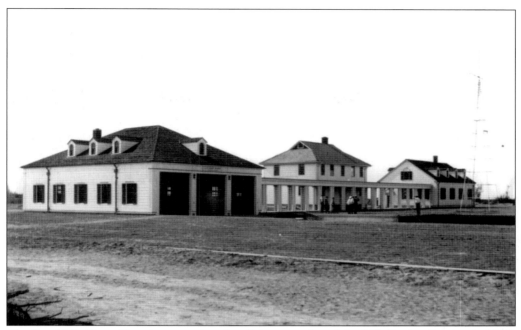

The first U.S. Coast Guard crew assigned to Fairport replaced the Life Saving Service in 1915. In 1939, they also replaced the U.S. Lighthouse Service. This picture shows the addition made to the U.S.C.G. station in 1938.

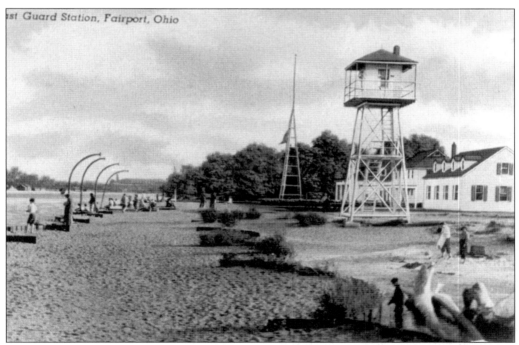

The Fairport station was used as a training center for the Coast Guard during World War II. Notice the guard tower.

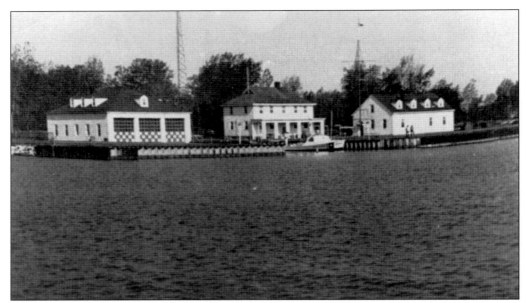

Pictured here is the Fairport Harbor Coast Guard Station and its patrol boat, which serves the area.

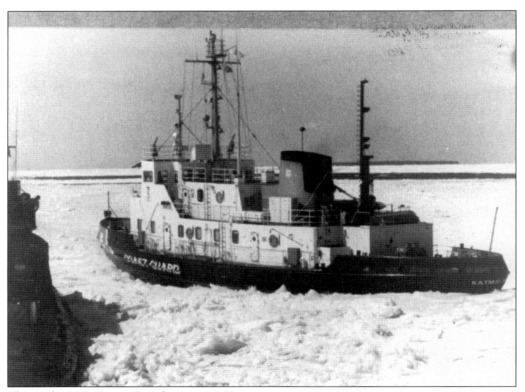

This is the U.S. Coast Guard ice cutter *Katma*.

Four

EARLY FAIRPORT
BUSINESSES

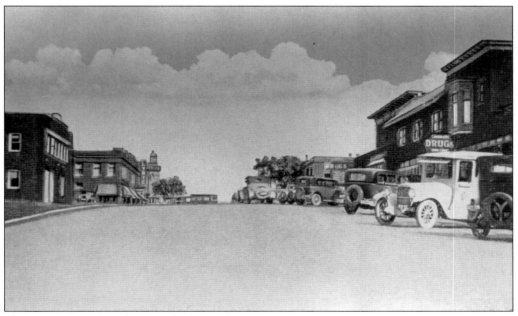

This 1925 view of High Street looks north.

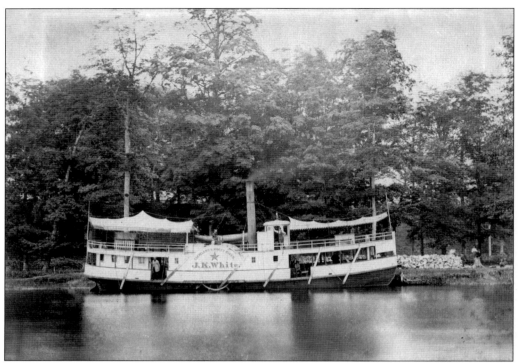

This 1870 photo shows one of several ferry boats that provided service between Fairport and Painesville. The *J.K. White* was a wood-burning side-wheeler with a canopied upper deck. In 1890, a round trip from Hine's Landing (North State Street) to the Life Saving Station cost 25¢.

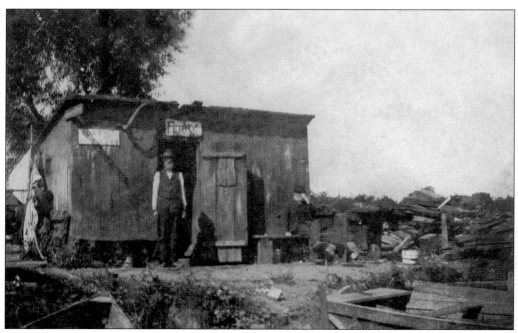

Pictured here is an early ferry service from Grand River to Fairport Harbor.

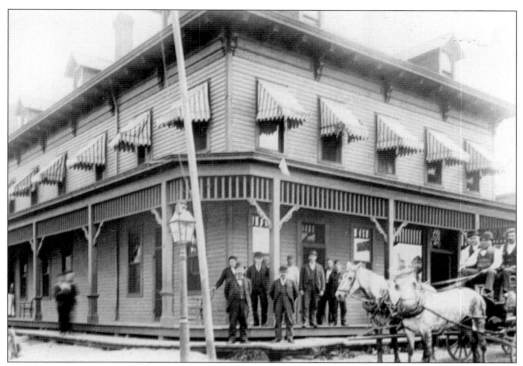

The McCrone House was located on the southeast corner of Second and Water Streets, c. 1890. The hotel burned in the disastrous fire of October 13, 1890, when 14 establishments were destroyed.

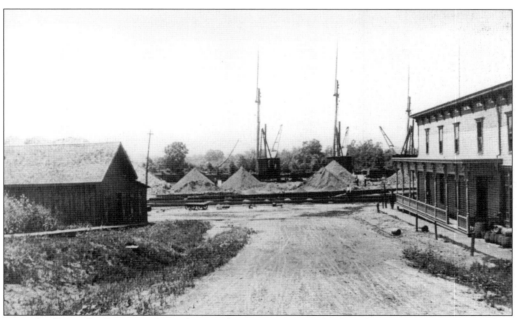

Jones Hall was built in 1845 on the northeast corner of Third and Water Streets. Unloading rigs can be seen in the background.

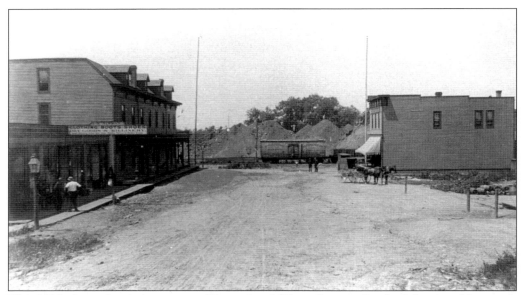

This 1892 photo shows the corner of Second and Water Streets. On the left side is Newman's Clothing Store and McCrone House. On the right side is E.E. Lawrence's two-story meat market.

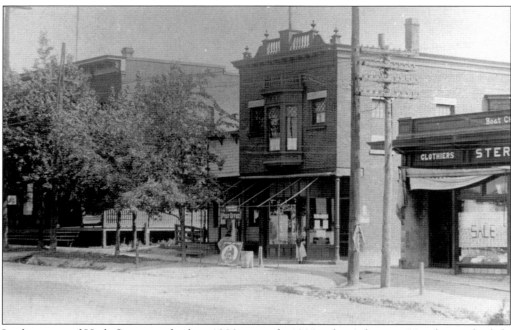

In this view of High Street in the late 1920s or early 1930s, the Arlington Hotel is at the left, followed by the post office. The building with the bay window later became Colgrove's Drug Store. Next in the row is Stern's Clothing Store.

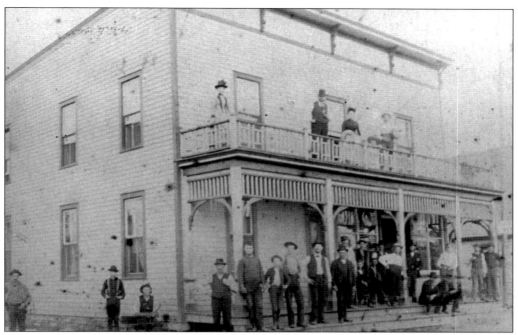

The Wolff Hotel, seen in this 1890 photograph, was located on Water Street.

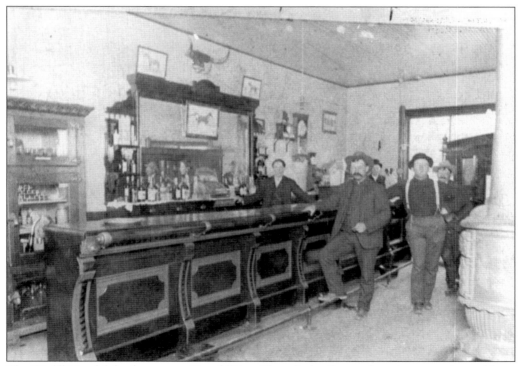

The Wolff Hotel (also known as Grand River House) also featured a saloon, as pictured here in 1890.

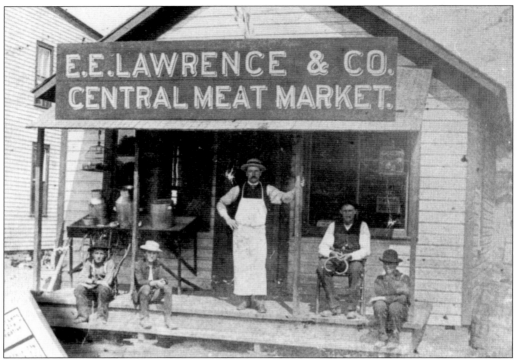

The first store operated by E.E. Lawrence opened in 1898 on Water Street. Pictured from left to right are Dan Fifield, John Johnson, E.E. Lawrence, Bill Johnson, and a Sullivan boy.

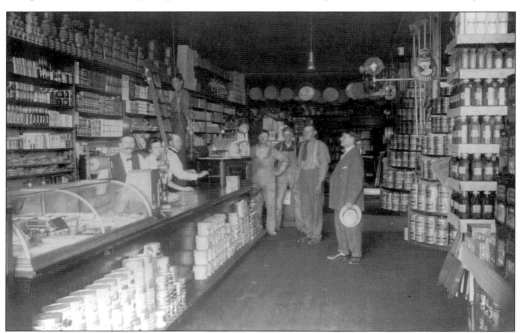

Mr. Edward Lawrence Sr. is at the cash register of E.E. Lawrence's Grocery Store, located on the northwest corner of High and Third Streets.

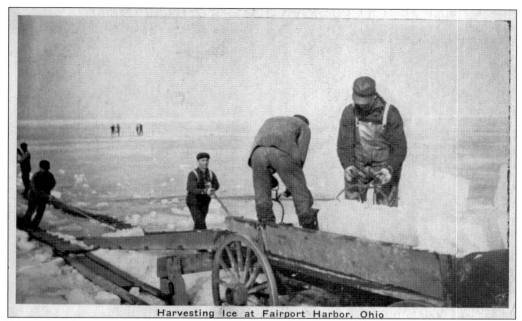

Harvesting Ice at Fairport Harbor, Ohio

As seen in this Fairport Harbor photo captured in 1915, harvested ice was scored into sections and cut by saw. It was then stored in wooden ice houses along the river. Much of it was used to preserve fish and other foods sent to suppliers. Also, most homes had ice boxes, which held 25–50 lbs. of ice.

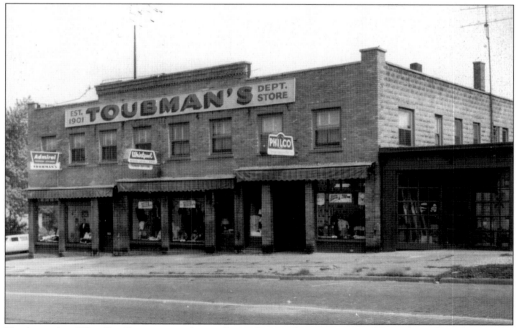

Toubman's—The Big Store—was located on the southeast corner of Fourth and High Streets. The store opened in 1901 and closed in the early 1970s. It is now the site of a bank and a convenience mart.

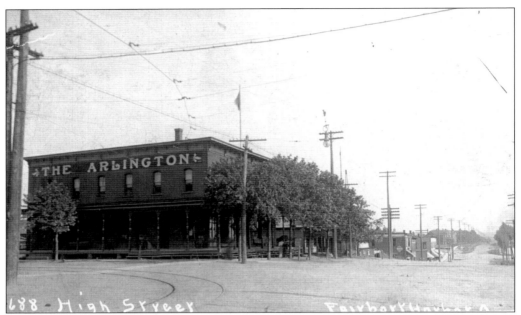

This 1908 postcard shows the Arlington Hotel on the southeast corner of Third and High Streets. It was built in 1889 and was destroyed by fire on March 8, 1931. Notice the streetcar tracks in the foreground.

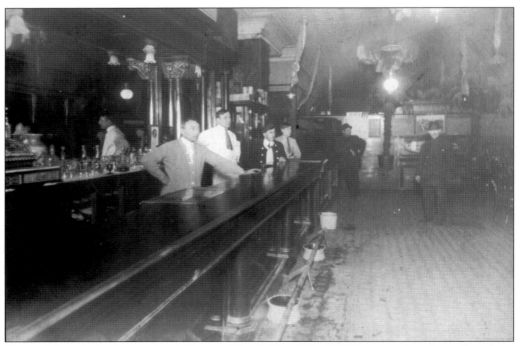

Pictured here is the bar at the Arlington Hotel. The 1901 DOW tax receipts show that there were 52 saloons in Lake County, and Fairport had 28 of them. It was said that little water was drunk on Water Street in its early days.

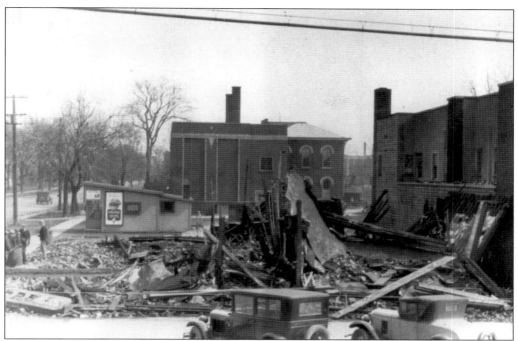

The Arlington Hotel was in ruins after the fire in 1931.

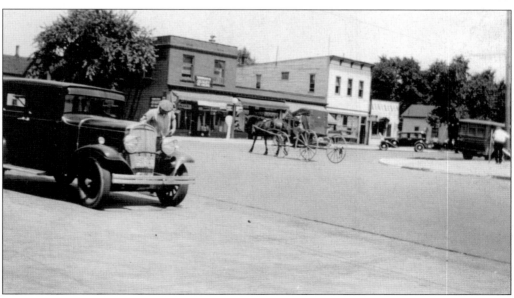

Noonan's Confectionery Corner, now known as the Gottwig Place, was located on the northeast corner of Third and High Streets.

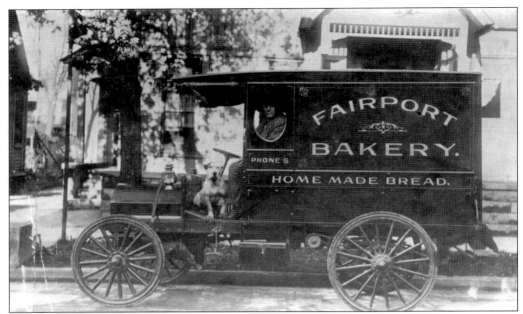

Matt Tuuri, the proprietor of Fairport Bakery, is at the wheel with his dog, Tom. The bakery was in business from 1898 to 1926. It is said that this was the first truck in Lake County. Note that the telephone number is "5".

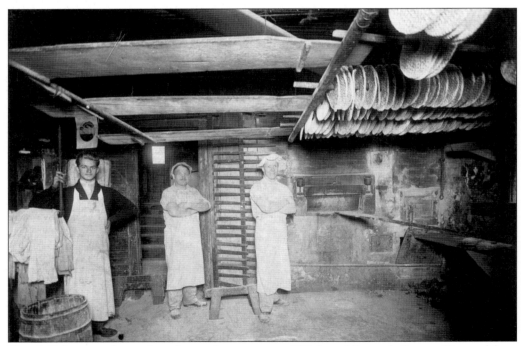

Tuuri's Bakery was located on the northeast corner of High and Seventh Streets. Pictured from left to right are John Laitinen, Adolph Suonio, and unidentified.

Zion Lutheran Church Cemetery, located on East Street, was dedicated by the Reverend K. Salovaara. The property was purchased from George Steele in 1903 for $300.

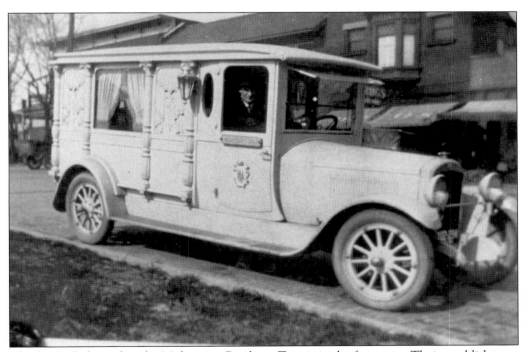

This hearse belonged to the Mulqueeny Brothers. Tom is in the front seat. Their establishment began in 1922 and was originally located on High Street. Wakes were held in the home of the deceased. At times, the coffin was carried to the church by members of a lodge. Family and friends followed.

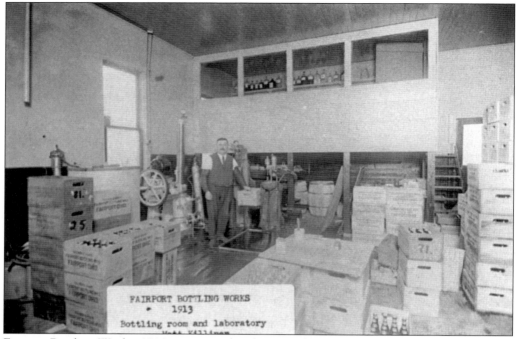

Fairport Bottling Works, 1913, was owned and operated by Matt Killinen.

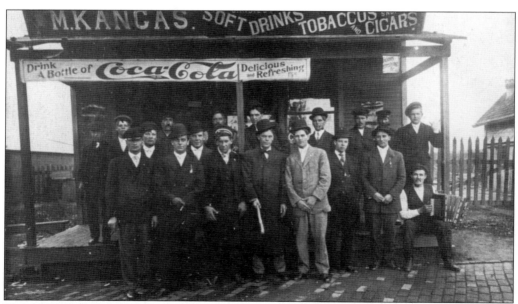

This 1907 photo pictures M. Kangas's store located on High Street. Rich's is located at this site today. Pictured here, from left to right, are the following: (front row) Oscar Hakala, August Bailey, Emil Karhu, Matt Kujala, John Taipale, John Karhu, Pete Concoby, Jack Annala, and Matt Kangas; (back row) Bill Kankaanpaa (Concoby), John Saari, Mr. Rintaluhta, Matt Nortunen, Harvey Concoby, unidentified, unidentified, Jack Wakkila, Antti Luoma, and Albert Hilston.

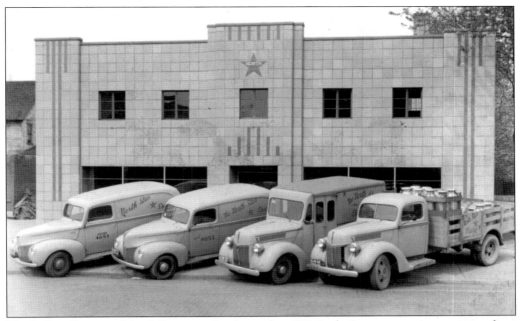

North Star Dairy and its delivery trucks, located at 533 Eagle Street, were in operation from 1935 to the 1960s. North Star was a cooperative stock company. Stock was owned by farmers and consumers. Isaac Ruusi Jr. was president and Lauri Hirvi was manager.

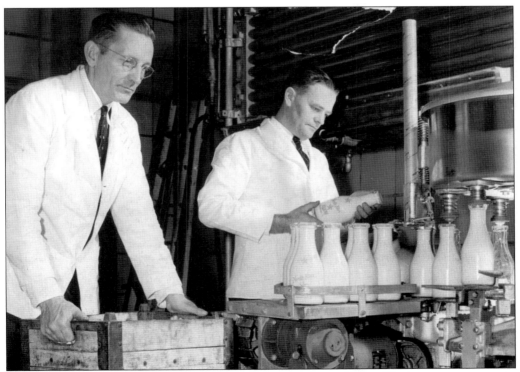

Pictured here are North Star Dairy employees Matt Kiikka and Lauri Hirvi.

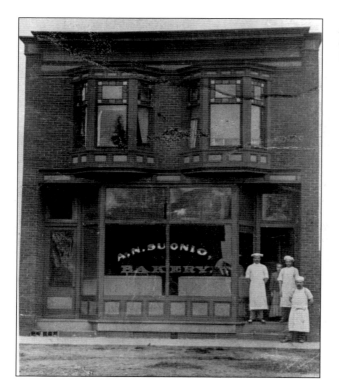

A.N. Suonio Bakery, located at 640 High Street, began operating in 1902.

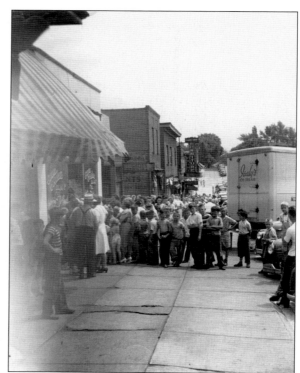

This is the grand opening of Isaly's Ice Cream Store at 316 High Street. Locals lined up for free cones, *c.* mid-1940s.

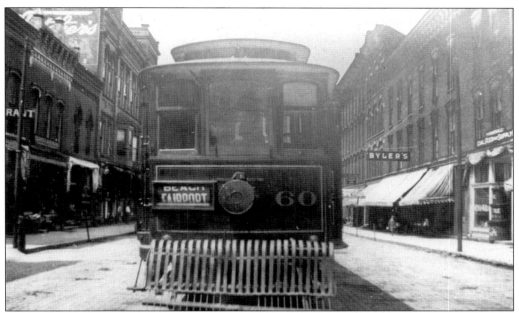

Pictured here is the Fairport-Painesville streetcar on Main Street in Painesville.

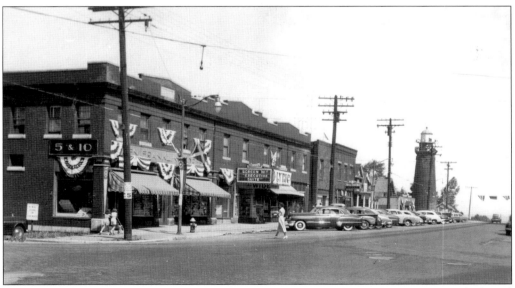

This view of High Street looking north from Third Street shows the Lawrence Block and includes the Ben Franklin five-and-dime store and the Lyric Theater. Other businesses included a barber shop, Beacon Market, Casella Dry Cleaners, the post office, and an appliance store. The lighthouse tower is at the far right. The 1954 film *Executive Suite* was playing at the Lyric on a wide screen!

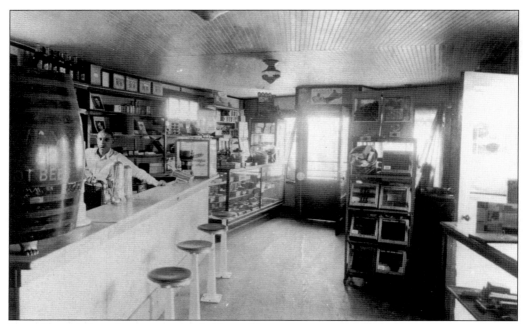

Steve Kanyuh is at the counter inside Kanyuh's gas station and deli on the southwest corner of East and Second Streets, *c.* 1930.

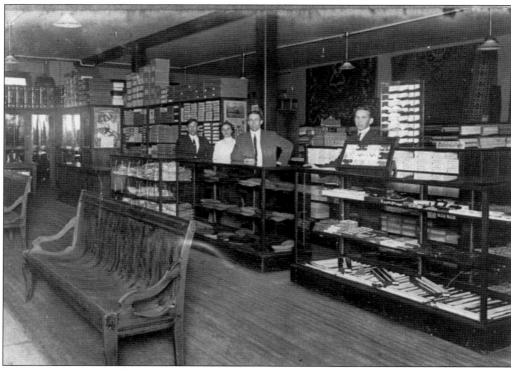

McCrone's Dry Goods Store was located on High Street until 1938–39. Later the location became the A&P Grocery Store.

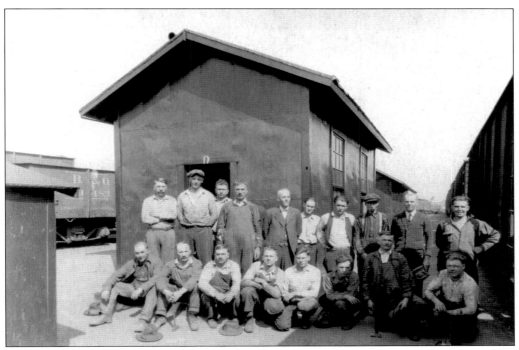

Fairport, Painesville & Eastern (FP&E) railroad car shop and roundhouse employees posed for this photograph in 1926.

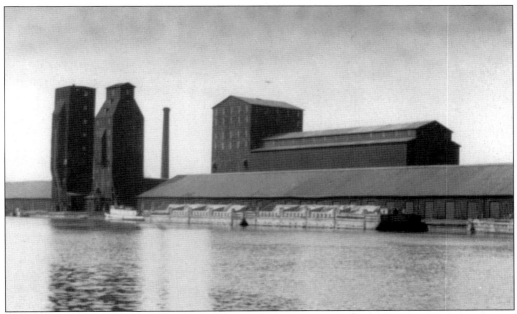

Originally the Fairport Warehouse and Elevator Company built in 1890 in Richmond, this building was intended for storage and shipment of grain and general merchandise. Employees received 15¢ per hour. The facility was sold to the A.E. Staley Company (a soybean plant) in 1939 and ceased operation in 1969.

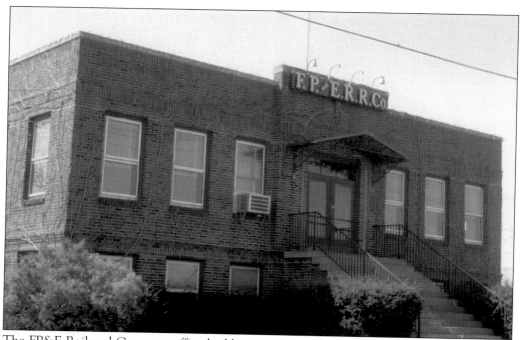

The FP&E Railroad Company office building was located on Third Street. The last diesel to come into the yard was on June 28, 1984, and the company closed on June 30, 1984. The building was demolished.

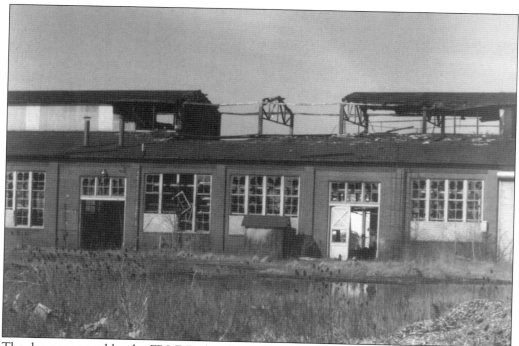

The damage caused by the FP&E Railroad roundhouse fire in April, 1991, can be seen in this photograph.

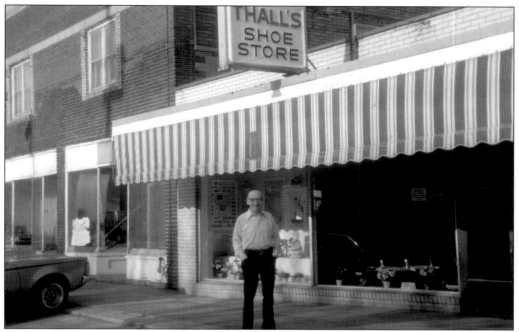

On June 14, 1948, Don Thall opened his shoe store on High Street between Ford Andrus Insurance Agent and Rogat's Hardware Store. There were three other shoe stores in the area—Simon's, Art McCrone's, and Toubman's. He relocated to his present location at 614 High Street in May 1957. At the age of 86, he is the oldest merchant in the village.

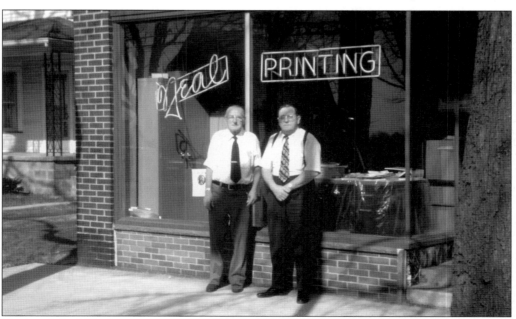

Neal and Carl Katila were owners, publishers, editors, and managers of the *Fairport Beacon*, which was founded in 1935. It had a circulation of 2,100, with yearly subscriptions available for $1 or $3 dollars if mailed. The last issue was published February 13, 1959.

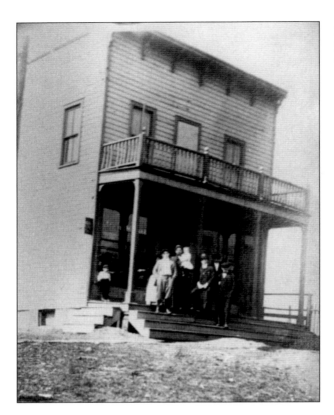

Molnar's Saloon was located at 945 High Street. This photo was taken in 1917.

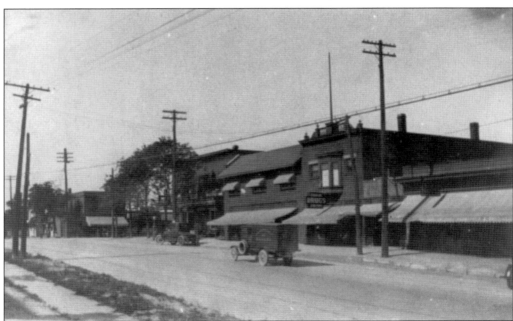

This 1923 photo of High Street shows the Arlington Hotel, McCrone's Store, Colgrove Drug Store, and Stern Brothers.

Five
FISHING

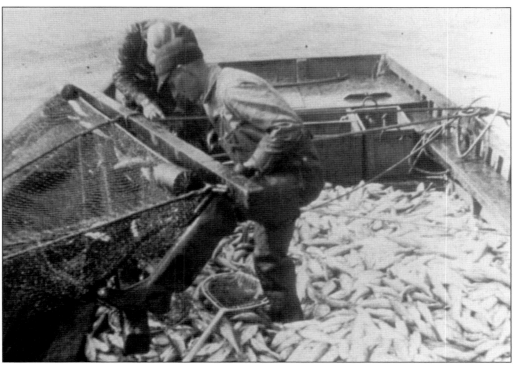

Pictured here are the tons of fish being brought in to be sorted and readied for shipment to various markets.

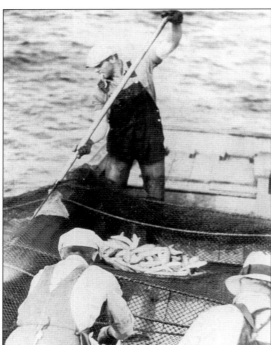

Grand River fishermen Lou Gurbach Sr., Andy Stalker, and Dan Stalker are hard at work.

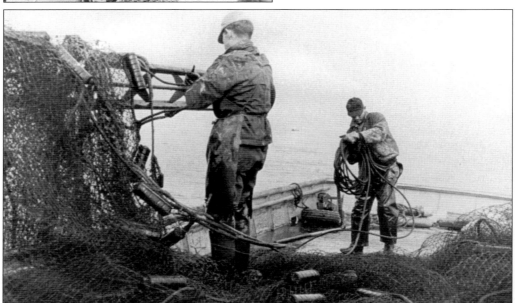

Fairport fishermen prepare to drop their nets into the lake. In the spring of 1869, Charles Ruggles introduced net-fishing in Fairport with four nets. The first season he had 1,500 sturgeon among his catch. It was an unfamiliar fish to the locals, and there was no market for sturgeon as food, so he sold them to Storrs and Harrison Nursery for $1 a wagonload to use as fertilizer. In 1870, Hart Pincus arrived in Fairport and set up a caviar business. He bought all the sturgeon from the fishermen. He converted bladders into isinglass and converted the rest into oil. He made a profit of $10,000 during his first season at Fairport.

William Stange, a local fisherman, caught this sturgeon on May 28, 1915; it weighed 57 lbs. and was 58 inches long. Thousands of sturgeon were caught by local fishermen.

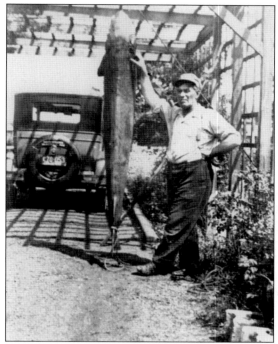

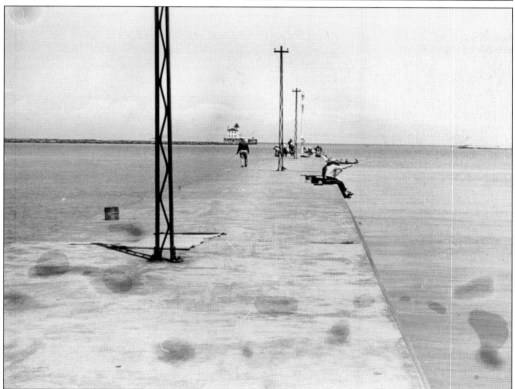

Pictured here is a relaxing afternoon spent fishing off the pier.

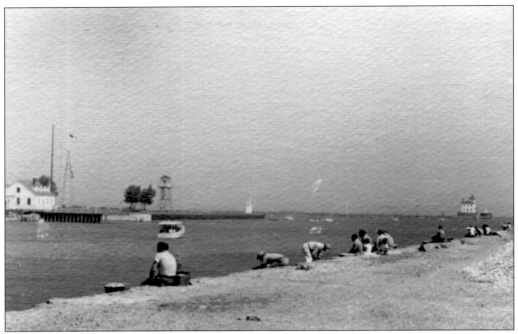

Fishermen cast their lines from the east pier across from the Coast Guard Station.

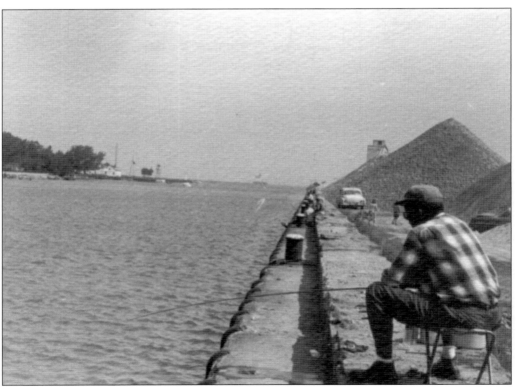

Fishing on the pier behind a stone pile.

Six
SCHOOLS AND SPORTS

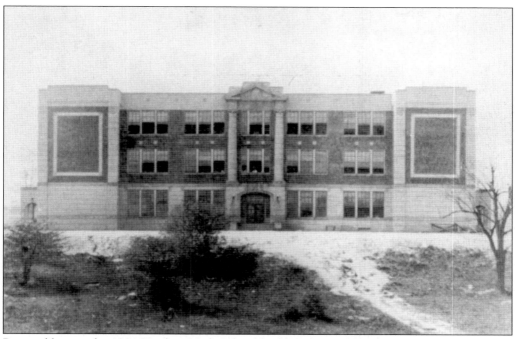

Pictured here is the 1921 Harding High School building. Note the gully in the foreground that would later become the football stadium.

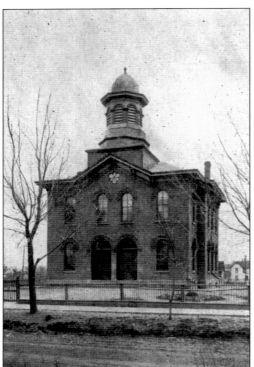

In 1924, Third Street School, pictured here, received an addition to the front of the building that was later named Garfield School. It now serves as our village hall and fire department.

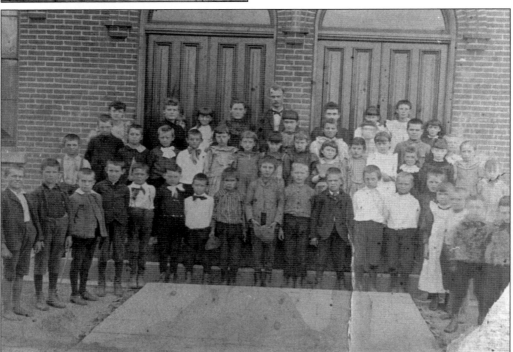

Here all eight classes of the Third Street School pose for their portrait, c. 1891. Thaddeus W. Byrnes, Supt., is at the top center.

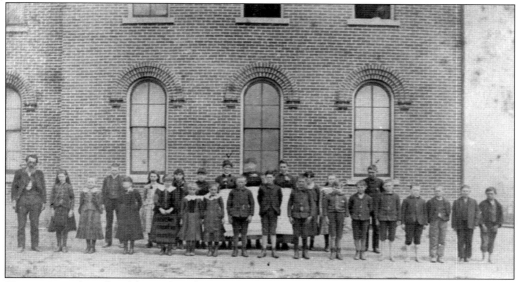

Hattie, Daniel, and Robbie Babcock are in the front row of this Garfield School picture. It was taken prior to 1889.

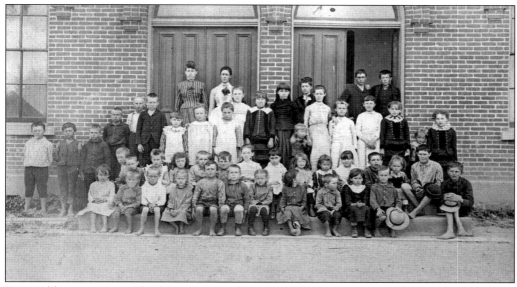

Pictured here are some Third Street School students. Notice how many children are barefoot.

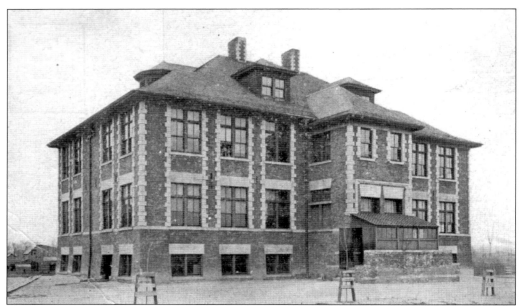

Fairport Harbor High School occupied two rooms of the Plum Street School. It was built in 1902.

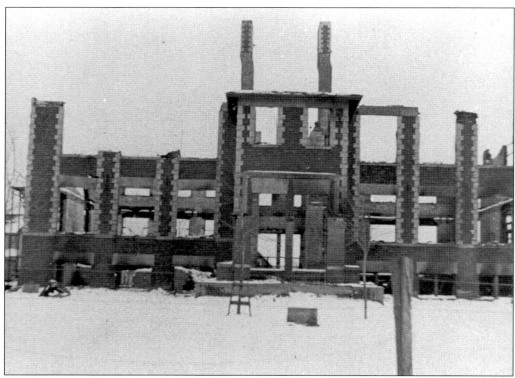

Fairport Harbor High School and Plum Street Elementary School were destroyed by fire on February 10, 1910.

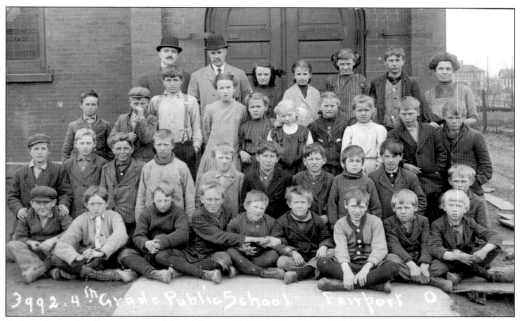

A fourth grade class poses at Third Street Public School, c. 1911.

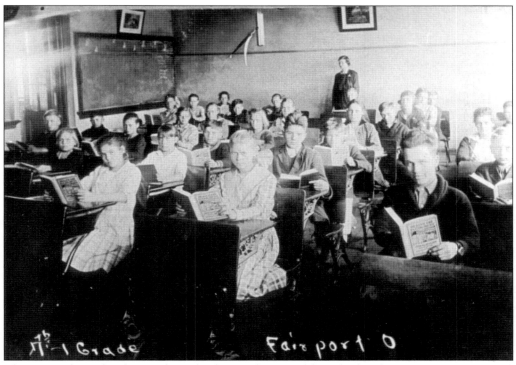

This McKinley School seventh grade class studies "Health and Cleanliness."

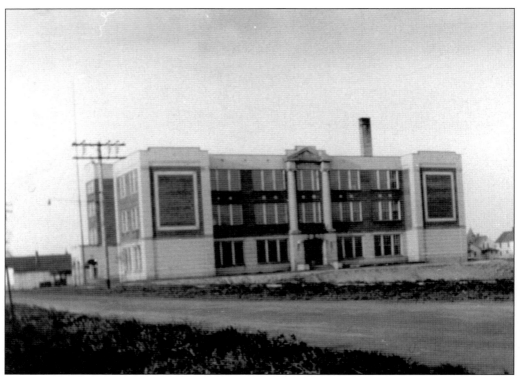

Fairport Harding High School stadium construction started in 1931.

Fairport Harding High School band room and gymnasium was constructed in 1954.

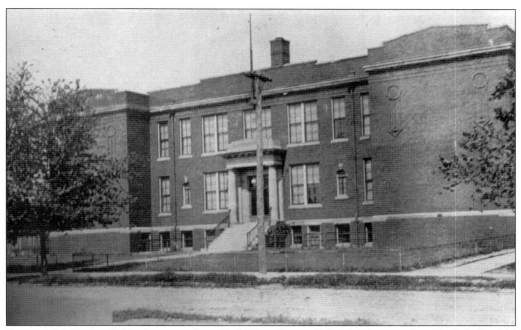

Fairport McKinley School, originally called Plum Street School, is pictured c. 1912. It housed only grades first through eighth. High school classes were discontinued, and students attended Painesville Harvey High School.

School nurse, Miss Evangeline Dann, bandaged cuts and bruises from 1920–1950.

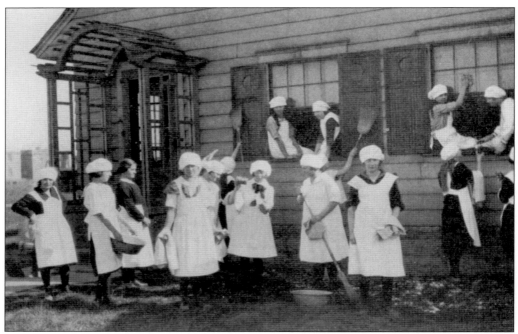

The home economics department kitchens were housed in the "Cottage," located at 516 New Fourth Street, from 1923–1930 because of lack of space at the high school.

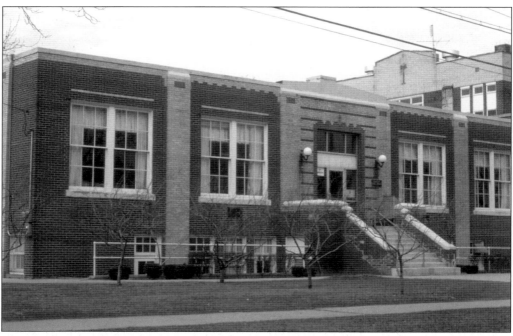

The Fairport Public Library was built as a Civil Works Project by the board of education and the board of library trustees in 1934. An addition that doubled the building's size and provided a band room was later built.

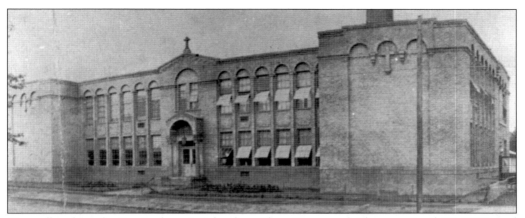

Groundbreaking for St. Anthony's School on Plum Street took place on April 17, 1926, and the building was completed in December, 1926. The school was closed in 1986 due to declining enrollment.

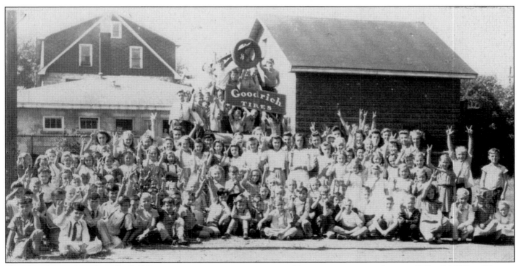

St. Anthony's school children participate in a tire collection project during World War II.

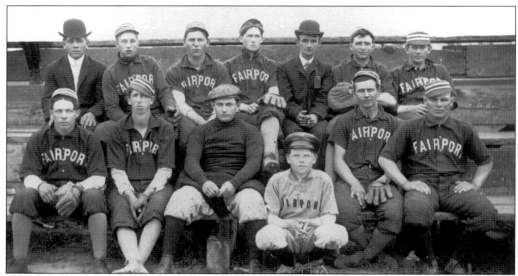

This baseball team represented Fairport in the early 1900s and was one of the scrappiest teams that ever took to the field. Strong rivalry existed between this team and the teams from Painesville and Richmond. Games hardly ever went over four innings; it usually ended up in a regular fist fight. Pictured here from left to right are the following: (front row) Art McCrone, Jay Lawler, Joe Burns, Roseman Harris (mascot), "Slugger" Wilson, and Walter Parish; (second row) Frank Motsch, Art "Jigger" Barnes, John Sakutney, Lester Lee, "Ginger" Brown, John Pennock, and Fred Fredebaugh.

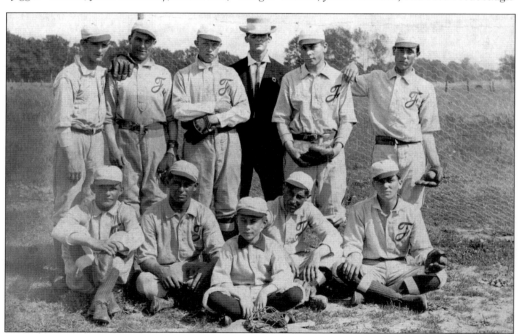

The Fairport baseball team of 1905 is pictured here, from left to right, as follows: (front row) Jack Cooper, Ike Stange, Albert Moore (mascot), Jack Annala, and Bill Bailey; (second row) Fred "Nifty" Brown, Gus Bailey, Art "Jigger" Barnes, Steve Sullivan, Art "Dutch" Henry, and Ray "Bucky" Joles.

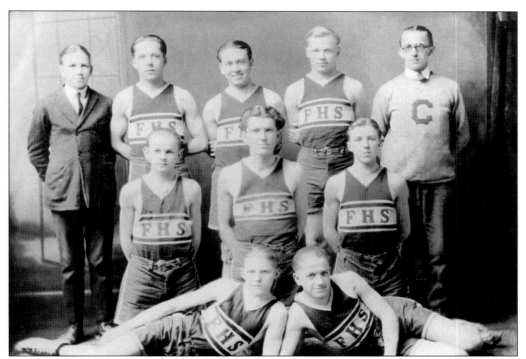

The 1924 Fairport High School basketball team is pictured here, from left to right, as follows: (front row) Ed Manninen and Carl Pohto; (second row) Albert Mackey, John Liikala, and Bernard Marshall; (third row) George Wakkila, Reuben Pohto, Vernie Hilston, Nap Oinonen, and Coach John Pohto.

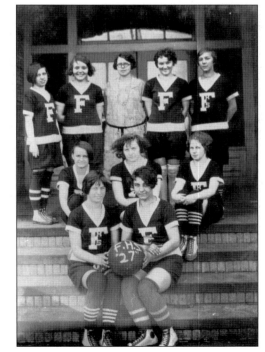

The 1927 Girls "A" basketball team is pictured here, from left to right, as follows: (front row) Anna Orosz and Bertha Stange; (second row) Iris Parrish, Hilda Ivary, and Ina Hervey; (third row) Lempi "Faye" Lampella, Bertha Kulberg, Coach Mrs. Marshall Tribby, Florence Mackey, and Esther O'Janpa.

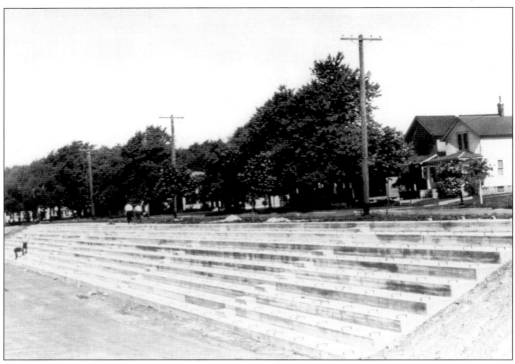

Pictured here are the new stadium bleachers under construction in 1931.

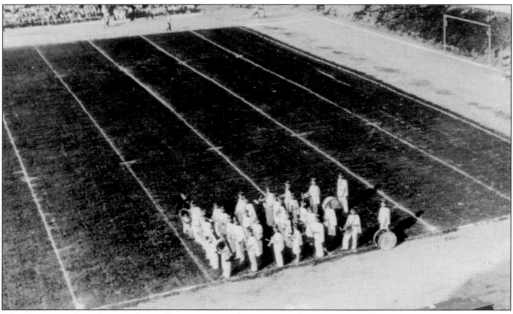

The Fairport band attends its first game in the new stadium on October 3, 1931.

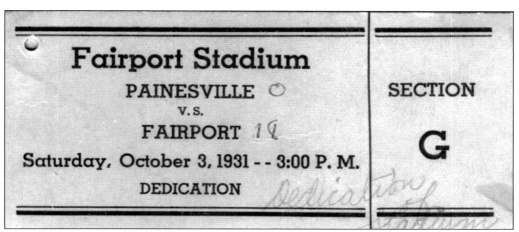

Here is a ticket for the dedication of the Fairport Harding High School football stadium on October 3, 1931. Final score: Fairport: 18, Painesville: 0.

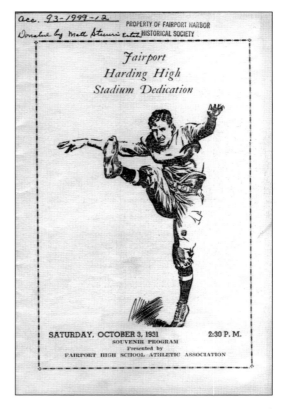

The Fairport Harding High stadium dedication was held on October 3, 1931.

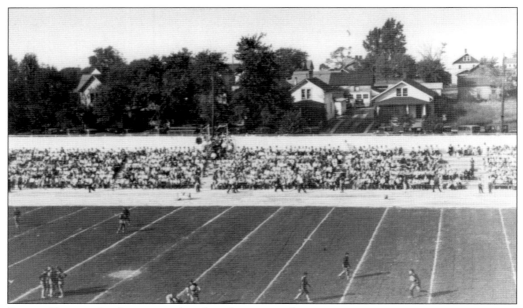

Pictured here is the first game played in the new stadium.

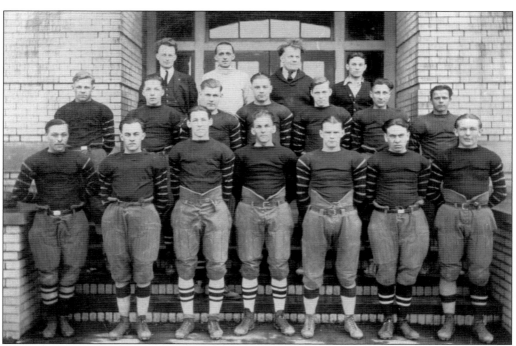

The 1922–23 football squad members are pictured here from left to right as follows: William Kivimaki; Norris Fredebaugh; Albert Katila; Victor Congos; Tom Somppi; Vernon Hilston; and John Kulberg; (second row) Nap Oinonen; Reuben Pohto; Neal Hilston; Jack Knuttinen; Neal Katila; Paul Sutch; and George Sabadosh; (third row) George Wolff, coach; John Pohto, assistant coach; O.C. Raberding, assistant coach; and John Raudasoja, manager.

Seven

NATIONALITIES
AND CHURCHES

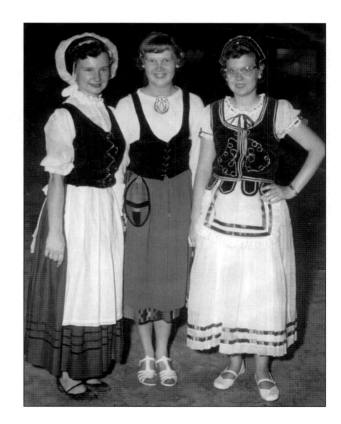

These Fairport residents represent three nationalities. Pictured here, from left to right, are LoGenia Ulle Keim, Slovenian; Nancy Mackey Lombardy, Finnish; and Eleanor Gurley Balog, Hungarian.

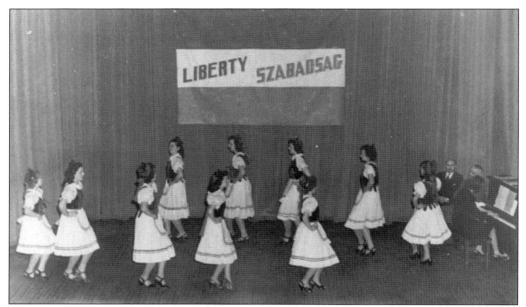

The dancers from the Hungarian Reformed Church are pictured from left to right as follows: (front row) unidentified, Helen Kish Steinback, Margaret Katko Esterle, Yolanda Vegso Bain, and Martha Szaniszlo Warden; (back row) Olga Esterhay Bowlin, Ida Szuhay Warren, Ada Orris, Julia Karako, and Betty Matty.

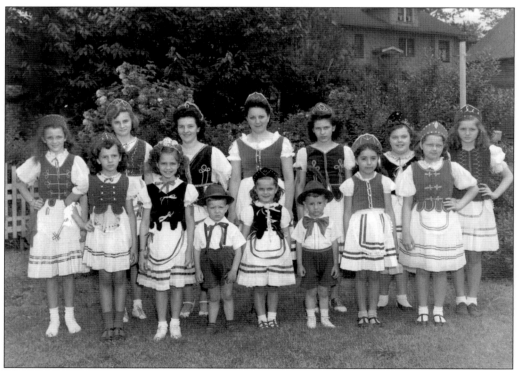

This Hungarian group participated in the Mardi Gras parade, c. 1948.

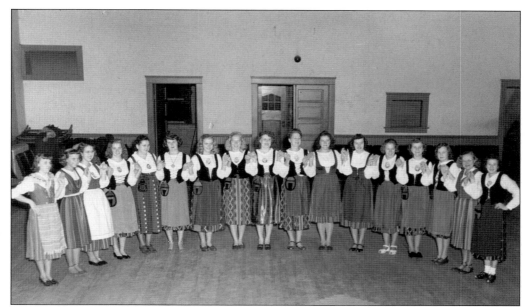

The Finnish Dancers, pictured here (*c.* late 1940s), from left to right, are Mary Ann Pietila Nagy, Jane Harri Aho, Alli Kauppinen Wiemero, Miriam Eklund, Ruth Harri, Shirley Beall Tantre, Lucille Hilberg Fundermark, Sally Saari Durochik, Pearl Saari, Lula Ahonen Hirvi, Aino O'Janpa, Mildred Hakola Laituri, Agnes Kallio Reho, Doris Klein Birch, Sylvia Mietty, Ruth Kylmanen, and Elvi Kallio Lampinen.

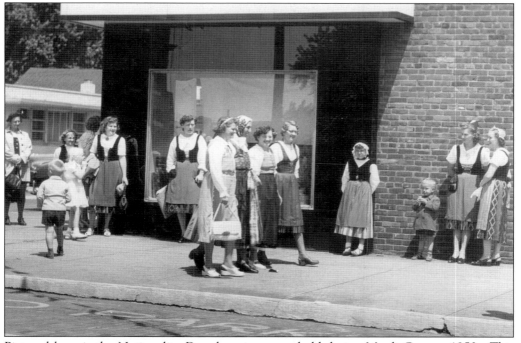

Pictured here is the Nationality Day shopping spree held during Mardi Gras, *c.* 1950s. This group includes Slovenians, Hungarians, and Finns.

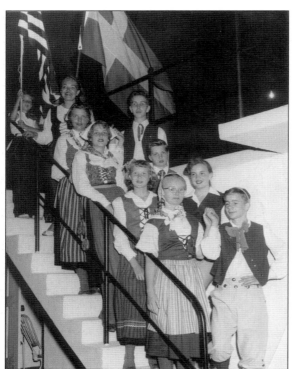

Here is an Estonian dance group at Fairport Mardi Gras.

Estonian dancers perform at the Fairport Mardi Gras.

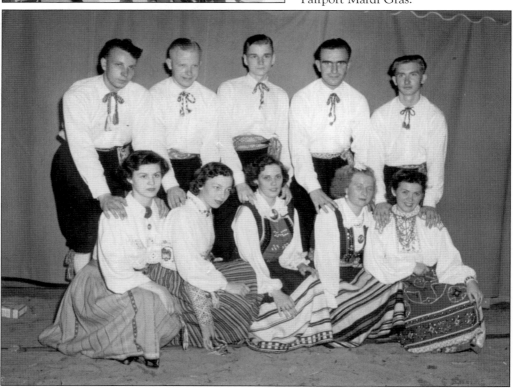

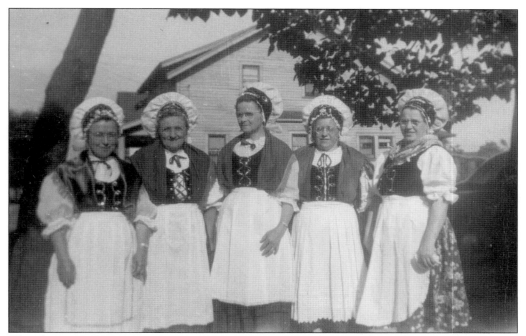

The Slovenian Dancers, *c.* 1948, are Josie Bajc, Mary Zalar, Angela Lunka, Mary Grzely, and Kristina Mahne.

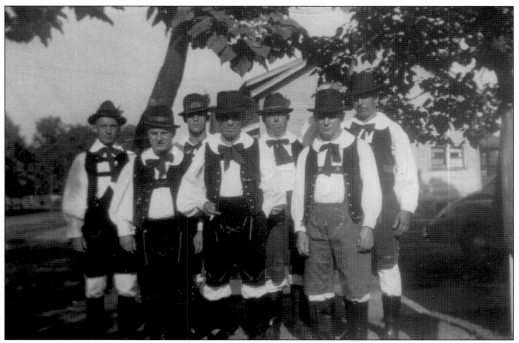

Slovenian Dancers, *c.* 1948, also include Lou Bajc, Charles Kapel, Hank Zalar, Lou Grzely, Lawrence Bajc, John Drobnick, and Andy Hervatin.

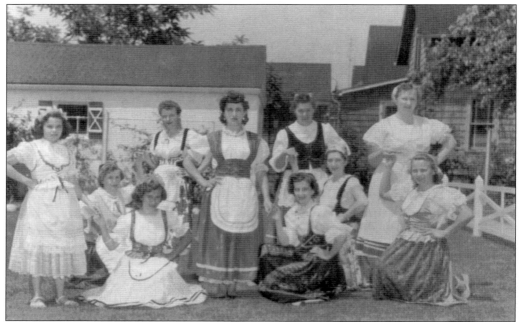

Slovak women dressed in native costumes pose in the early 1950s. Shown here, from left to right, are the following: (kneeling) Mary Kolesar Naumann, Paula Volanski McGee, Mary Paul Lamos, Rosalene Zimny Horvath, and Marion Hyduke Crofoot; (standing) Mary Ann Moroz McDonald, Olga Hyduke Shaw, Agnes Mikula McReynolds, Florence Palko Mohner, and Margaret Losz.

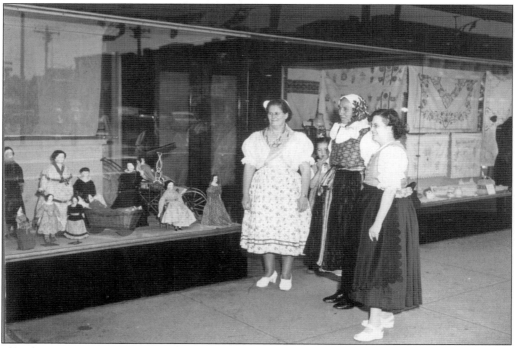

Slovak women in costume pose in front of a nationality display window during Mardi Gras.

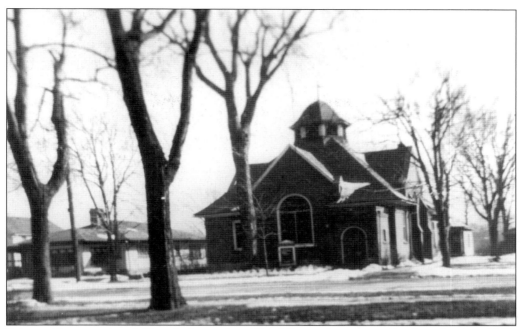

Fairport Congregational Church, located on Third Street, began as a Sunday school in 1869. The cornerstone was laid on August 5, 1869, and dedication took place on December 12, 1869. It has changed very little in appearance over the years. This is the oldest church in Fairport.

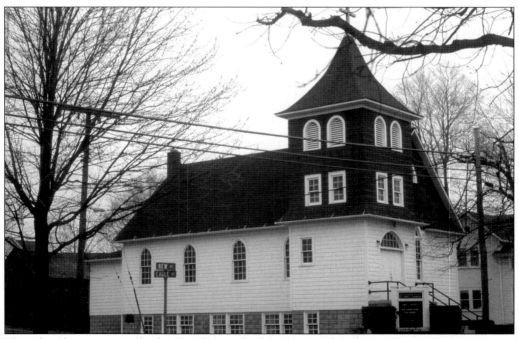

This church was originally the First Evangelical Lutheran Church, on the northeast corner of New and Eagle Streets. It was organized in 1890, and the cornerstone was laid in 1928. The church disbanded in 1990. Today this church serves as the Inspirational House of Prayer.

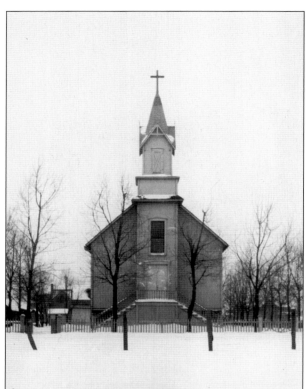

Immanuel Evangelical Lutheran Church, on the northwest corner of Sixth and Plum Streets, was organized in 1889. The sanctuary was built in the fall and winter of 1895–96 by volunteer workers.

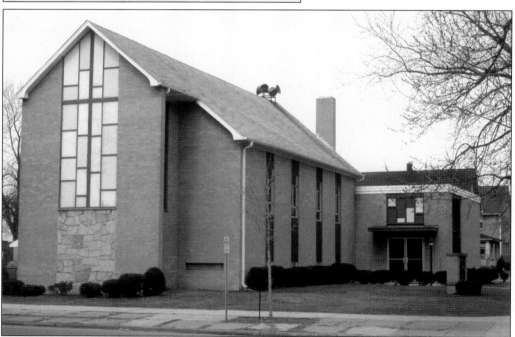

Pictured here is Immanuel Evangelical Lutheran Church as it looks today. Dedication services of the completely renovated church were held on July 12, 1964.

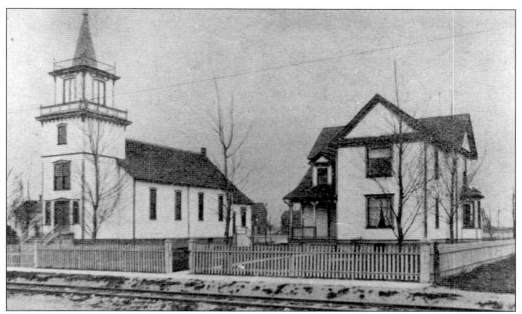

Zion Lutheran Church was originally located at 220 Seventh Street. It was moved to its present location at the southeast corner of Fifth and Eagle Streets in 1897. The bell was added in 1898 and still tolls today.

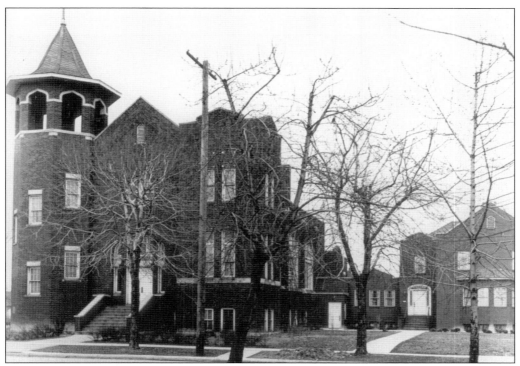

Pictured here is Zion Lutheran Church as it appears today. Construction began on April 1, 1924, and it was dedicated on August 30, 1925.

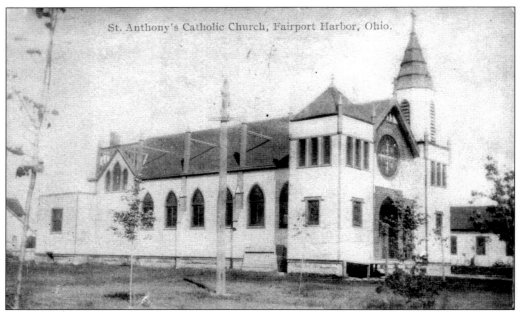

St. Anthony's Roman Catholic Church was built in 1899 on Plum Street. The cornerstone was laid in November 1899, and dedication of the sanctuary was on July 15, 1900. On January 5, 1903, Fr. Hegyi arrived in Fairport from Hungary, and on that day St. Anthony's became a parish. In 1926 the old church was moved to the back of the lot, and construction of the new church and school began. The church's interior was completely remodeled in 1975.

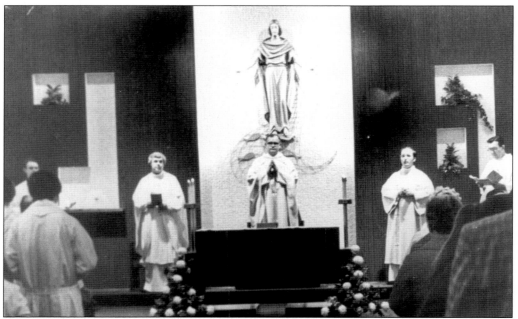

Dedication services of the newly remodeled St. Anthony's Church were held on January 11, 1976. Participating clergy, pictured here from left to right, were Fr. Norman Riley, Bishop James Hickey, unidentified, and Fr. R. Kline.

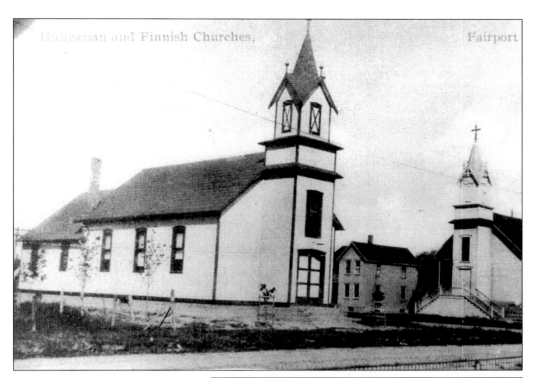

The Hungarian Reformed congregation was organized on October 23, 1910. This first sanctuary was built by C.T. Mighton Company on the southwest corner of Sixth and Plum Streets, and was dedicated in 1913. The Immanuel Lutheran Church on the right was built by the same builder and is almost identical in appearance.

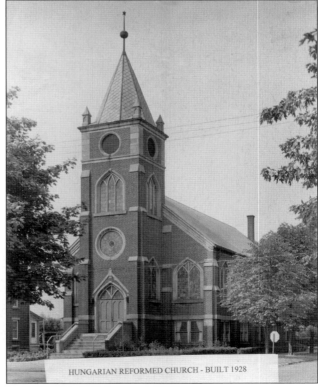

HUNGARIAN REFORMED CHURCH - BUILT 1928

The present Hungarian Reformed Church was built in 1928 on the same site as the old church.

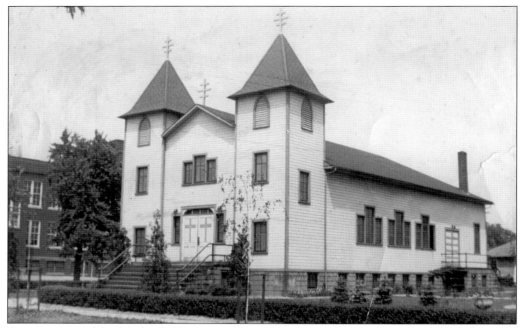

Construction of St. Michael's Byzantine Rite Church, on the southeast corner of Plum and South Streets, began in the spring of 1926 and was completed by fall.

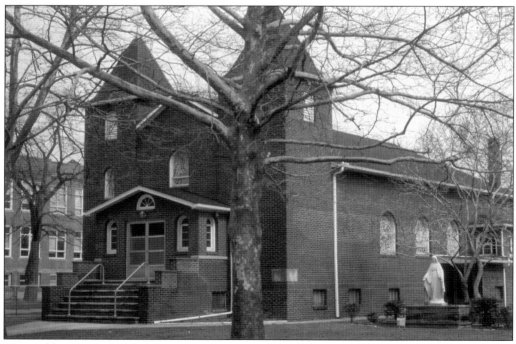

Pictured here is St. Michael's as it appears today. The church was bricked in 1944.

Eight

CITY SERVICES

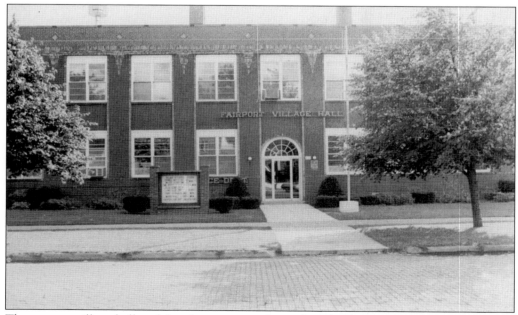

The present village hall and fire department is located in the former Garfield School on the southwest corner of Third and Eagle Streets.

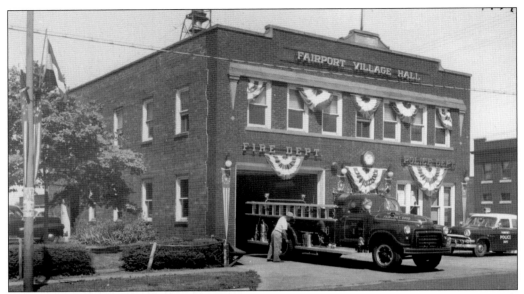

The former village hall and fire department was built in 1924 on the southwest corner of High and Third Streets. The building is now occupied by the Fairport Harbor Senior Citizens.

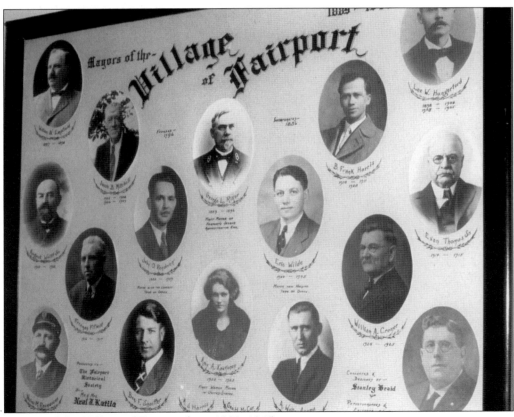

Mayors of the Village of Fairport from 1889–1945.

Leander Congos, Fairport marshal, stands in front of Fairport Harbor Post Office. Regular mail service was established in 1801. Addison Hills, Esq. was appointed postmaster in May, 1841, and relieved Elijah Dixon of the post. House-to-house mail delivery began in 1920.

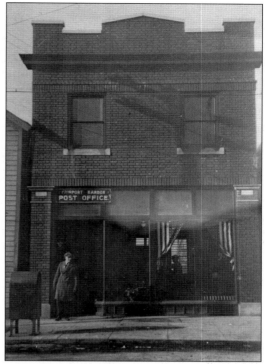

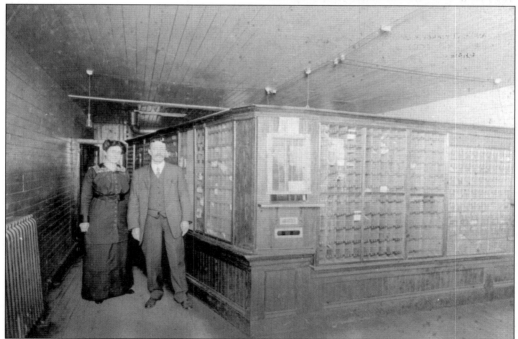

Harriet "Hattie" (Babcock) Warren and husband, Elias D. Warren, are pictured here in the post office located on the northwest corner of Third and High Streets. Elias D. Warren was appointed postmaster on May 6, 1913, by President Woodrow Wilson.

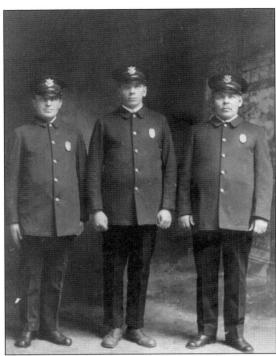

Fairport Police Department members pictured here are Steve Sutch, Leander Congos, and unidentified.

Fairport Police Department members are pictured here, from left to right, as follows: (front row) Angelo Caruso, Steve Paul, John Miller, and Bill Bumblis; (back row) Andrew Kraynik, Alex Maki, Frank Bates, Russell Meyers, and Joseph Sabo.

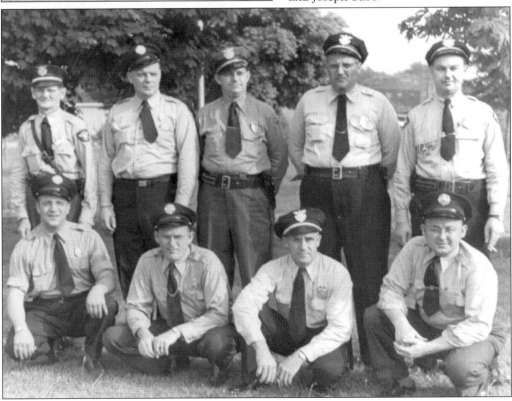

Here is Fairport's unidentified "Keystone Cop" in full uniform.

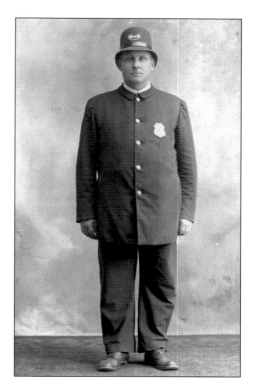

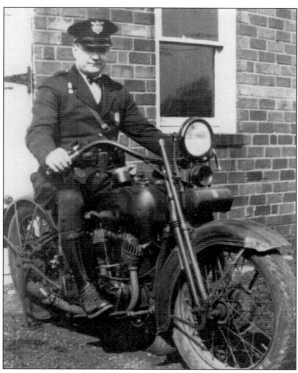

Steve Lefelhocz, patrolman, poses on an Indian Motorcycle.

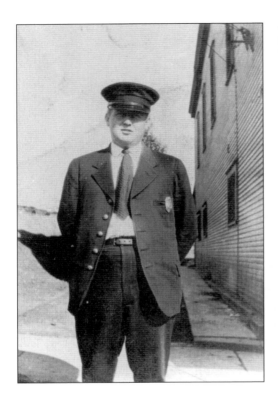

John S. Aho was marshal of Fairport from November 1917 to November 1919.

John Henry Werbeach Sr. was appointed marshal in 1919, 1920, and 1921.

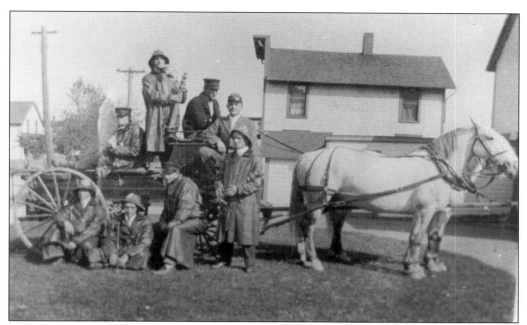

This photo of an early Fairport Volunteer Fire Department is undated. When the old fire bell was rung, the two fire horses of August Wolff were excited and ready to go. In 1912 the village had financial difficulties, and it was decided by council that the horses ate too much (the feed bill was $30 per month), so the horses were retired.

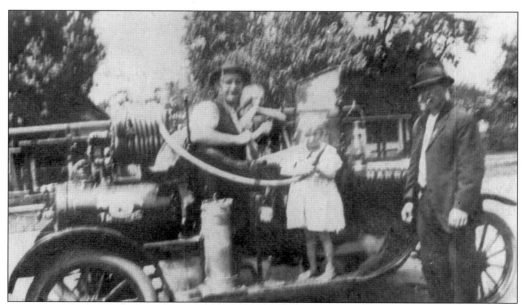

This is the Fairport Volunteer Fire Department chemical truck, a 1916 model purchased in 1917. Pictured, from left to right, are August Wolff, Thelma Wolff, and Jigger Barnes.

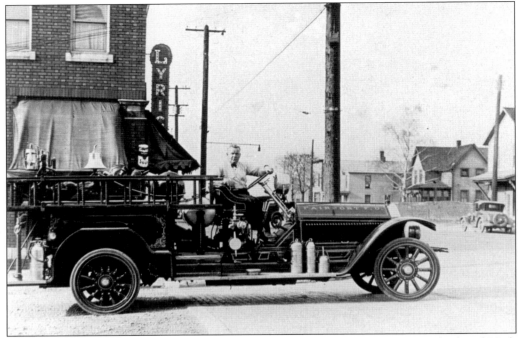

This American LaFrance 1922 fire truck stops near the southwest corner of Third and High Streets. In the background is the first marquee of the Lyric Theater.

This Fairport Fire Department chemical truck was purchased in 1917 for $960. Pictured here, from left to right, are August Wolff with axe, Jigger Barnes, and John Bartish.

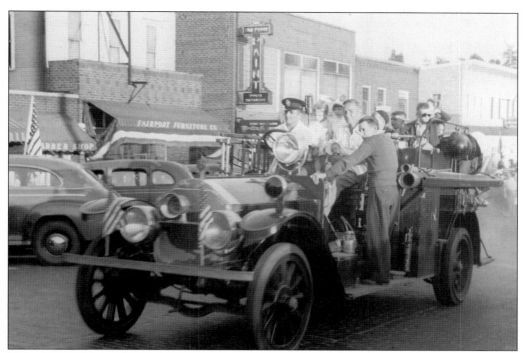

This antique fire truck was driven in the Mardi Gras parade.

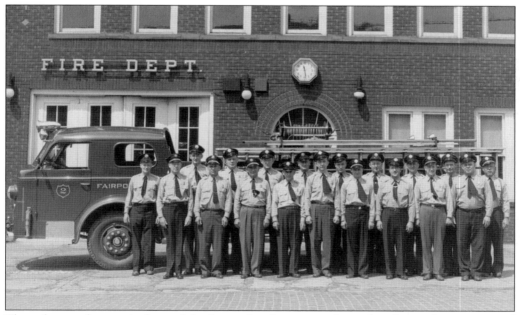

The volunteer firemen in front of the former fire department, located at the southwest corner of High and Third Streets, are pictured from left to right as follows: (front row) Frank Converse, Vernie Nortunen, John Morick, Andrew Hritz, Everett Hietanen, Ray Horvath, Angelo Caruso, Willis Royer, and Howard Bittner; (second row) Walfred Karhu, George Adams, Alex Maki, Steve Gaul, Steve Sutch, Tom Webster, William Bumblis, Edward Toth, and William Holson.

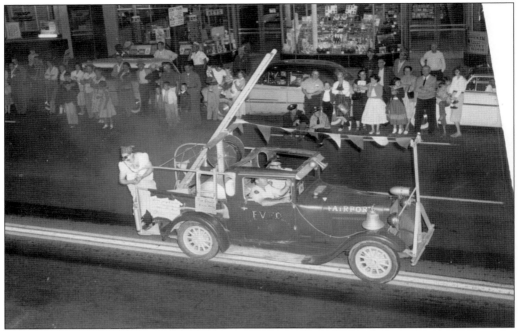

This old fire truck was used as a comic entry in a parade. This was a once-a-year event for firemen to have fun with the comic truck. Remember getting wet watching the parade?

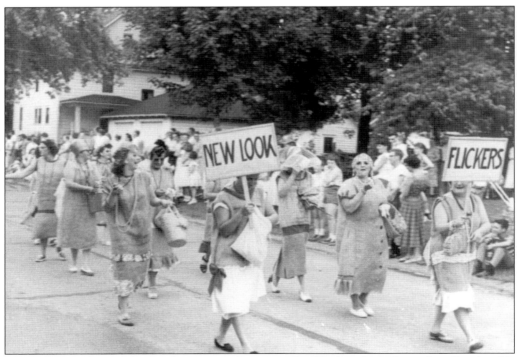

The ladies auxiliary of the fire department, known as the "Flickers," was formed on October 21, 1950. Here they are participating in the Fairport Mardi Gras parade.

Nine
INDUSTRY AND BOATS

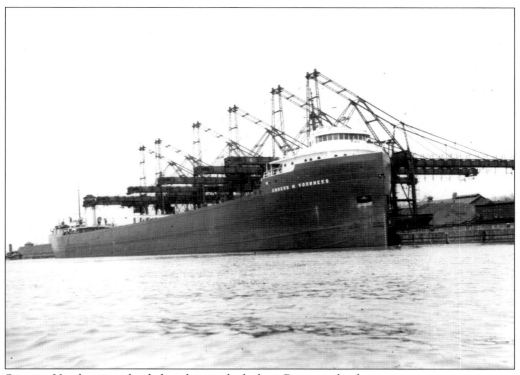

Steamer *Voorhees* is unloaded at the ore docks by a Brown unloader.

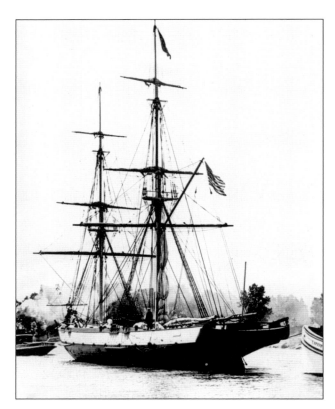

Commodore Perry's flagship *Niagara* heads up river, towed by the tug *Fairport* and followed by the *LaFayette*. These boats came to Fairport in July, 1913, to commemorate the 100th anniversary of Perry's victory on Lake Erie.

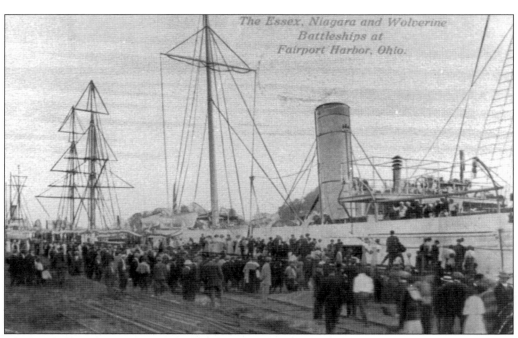

The battleships *Essex, Niagara,* and *Wolverine* dock at Fairport Harbor for viewing in 1913.

Tugboat *Annie* tows a sailing ship. Tugboats assisted the boats in maneuvering in and out of the harbor. Tugs became obsolete as boats acquired bow thrusters.

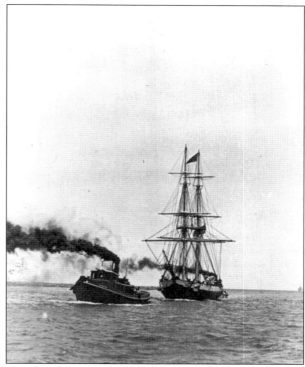

The *Wolverine* (originally the U.S.S. *Michigan*) was the first iron warship in the U.S. Navy. The foremast is now located at the Fairport Marine Museum.

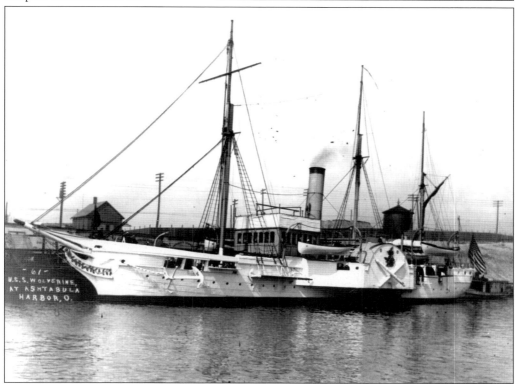

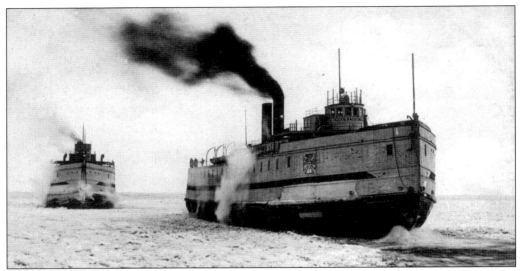

Lake boats break through the ice in Fairport Harbor.

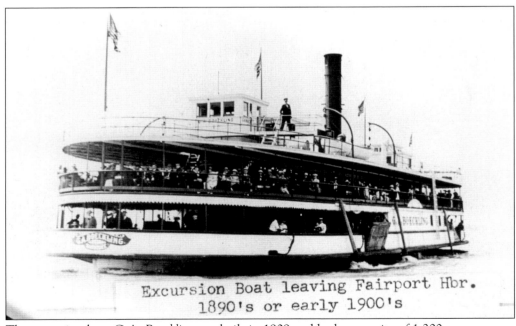

Excursion Boat leaving Fairport Hbr.
1890's or early 1900's

The excursion boat G.A. *Boeckling* was built in 1909 and had a capacity of 1,200 passengers.

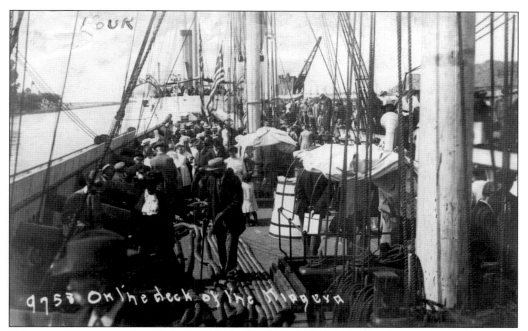

Schooner *Niagara* awaits visitors at Fairport Harbor in 1913. The price per person to board the schooner was 10¢.

Pictured here is a scene at the stone dock.

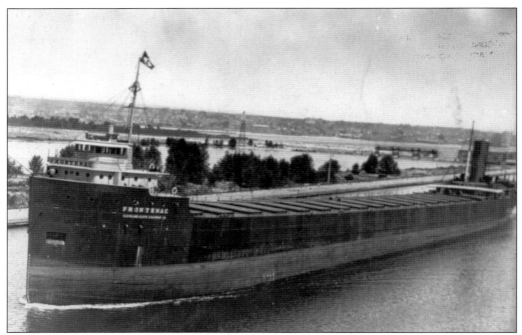

Steamer *Frontenac*, owned by the Cleveland Cliffs Transportation Company, was built in 1923. The pilot house was attached to our Marine Museum in 1967.

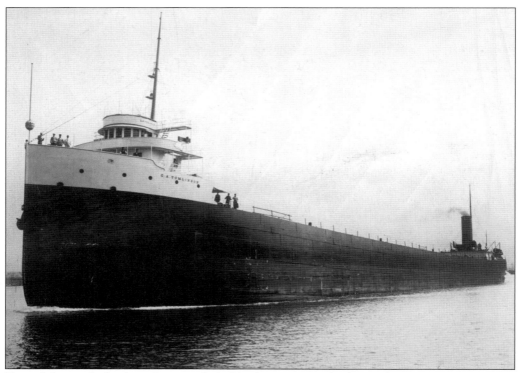

Two of the portholes from Steamer G.A. *Tomlinson* are on display in the Marine Museum.

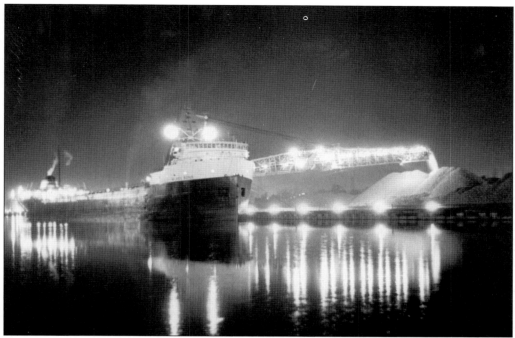

Pictured here is a stunning night picture of Steamer *McKee Sons*, a regular visitor to Fairport, c. 1950s.

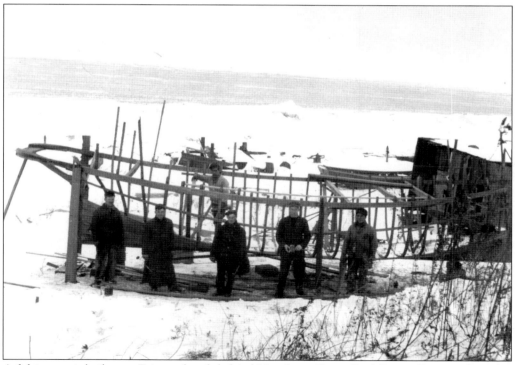

A fishing tug is built on a Fairport beach behind Houghton Court. Fred Stange Sr. is on the right.

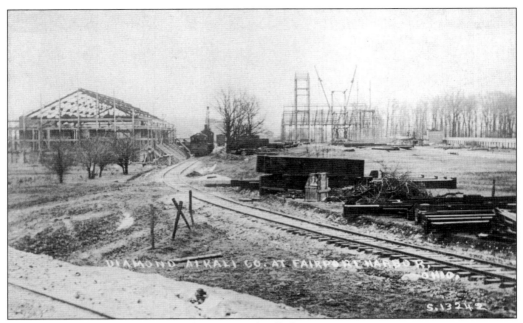

Pictured here is the beginning of the Diamond Alkali in 1912.

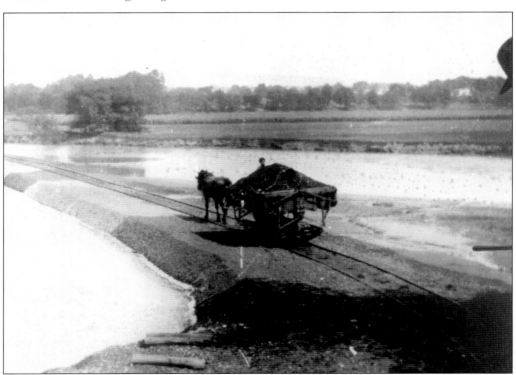

A dike for the Diamond Alkali Company is being built with horse and wagon on August 8, 1918. The man with the team is probably Matt Kortesmaki of the southeast corner of Seventh and Plum Streets. The dike was near the N. St. Clair Street bridge.

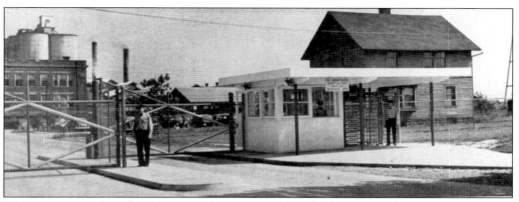

The new gates and gatehouse pictured here were used at the Diamond Alkali main entrance on Second Street during World War II.

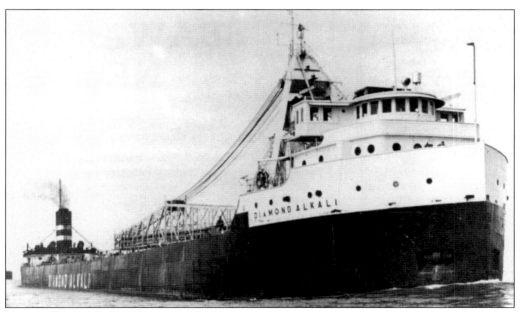

Steamer *Diamond Alkali* enters the harbor.

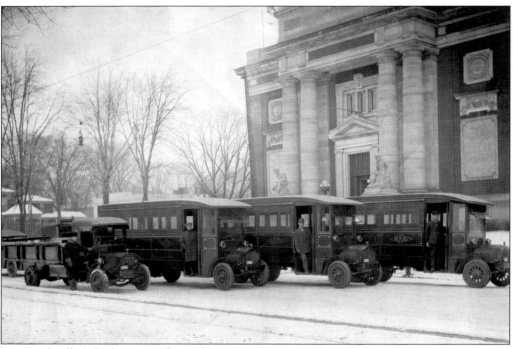

Diamond Alkali had its own fleet of buses used to transport workers from Painesville to the plant. This photo was taken in front of the courthouse in Painesville.

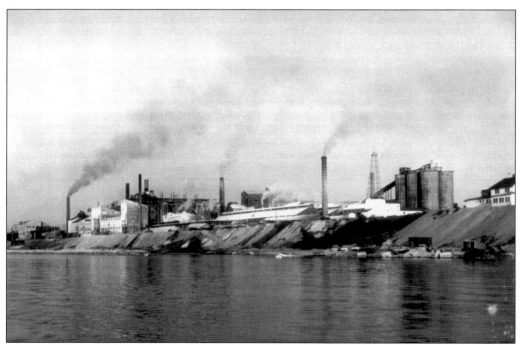

Here is a view of Diamond from Lake Erie. In its peak years, there were 5,000 employees. When it closed in 1976, there were about 1,000 employees.

Ten
FAIRPORT SCENES

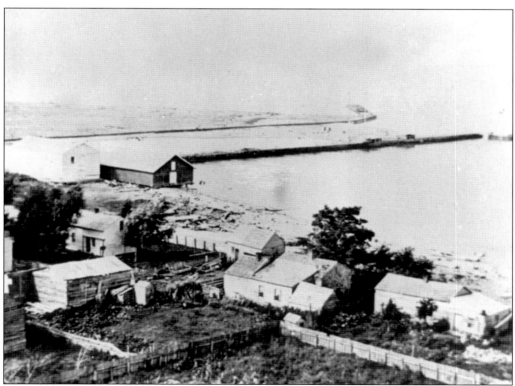

This is one of the oldest pictures of Fairport and the harbor, taken in 1858. This area is located below the lighthouse hill on the lakefront. Note the sandbar at the mouth of the river. The original piers, shown here, were built in 1825, and were filled with stone.

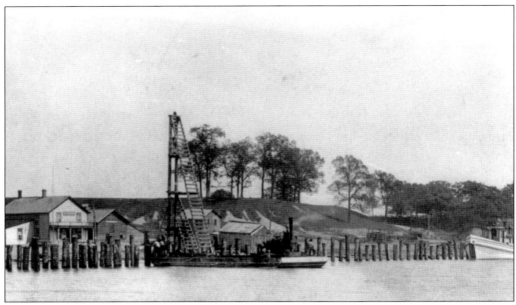

Here is the Fairport dock in 1882.

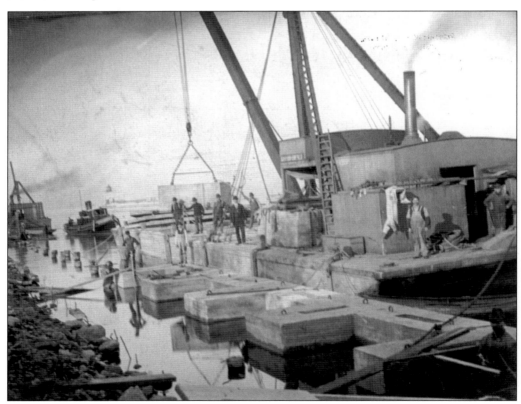

Tugboat *Albany* and the beacon erected on the east pier in 1875 are visible in the background of the construction of west pier.

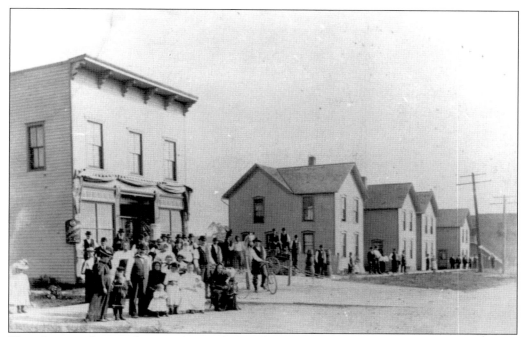

This photograph was taken in 1910 at the southeast corner of Seventh and High Streets. The Paytosh building was formerly a saloon.

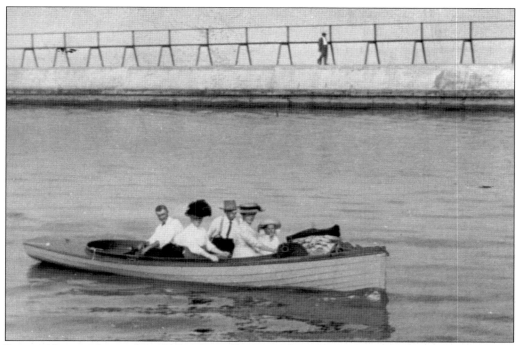

Pictured here in September 1915 is the walkway on the east pier. Boaters, from left to right, are Daniel Babcock, Mrs. Mary Babcock, Capt. Joseph Babcock, Mrs. Daniel (Elizabeth Stange) Babcock, and her niece, Dorothy Wickland Norman.

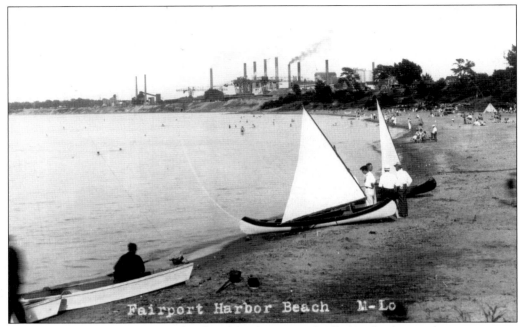

Here is a picture of Fairport Harbor beach with Diamond Alkali in background.

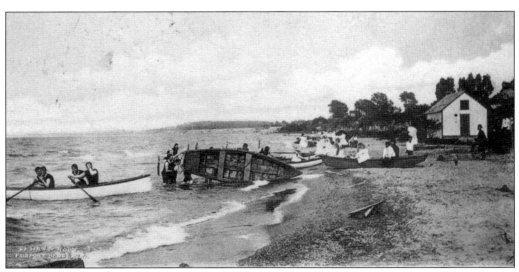

This is a 1907 scene of Fairport Harbor beach.

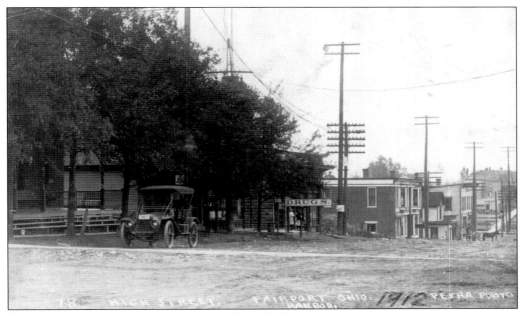

This early scene of High Street looks south, c. 1912.

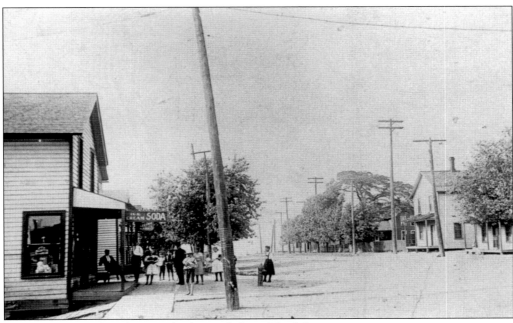

This 1908 view of High Street looks north from Third Street.

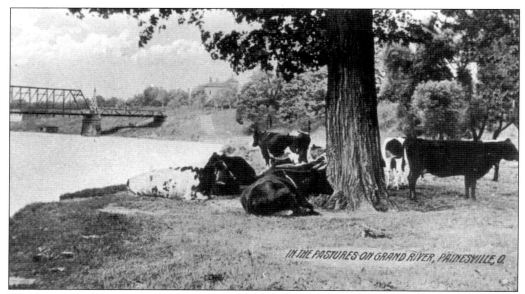

The location of this early scene along Grand River is where Fairport residents brought their cows to graze. Note the old iron bridge crossing St. Clair Street in the background.

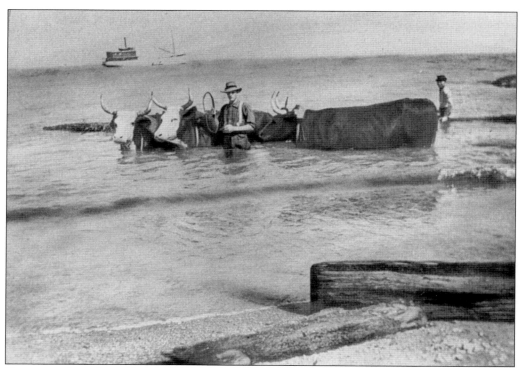

Oxen were brought to Fairport from the ship in the background.

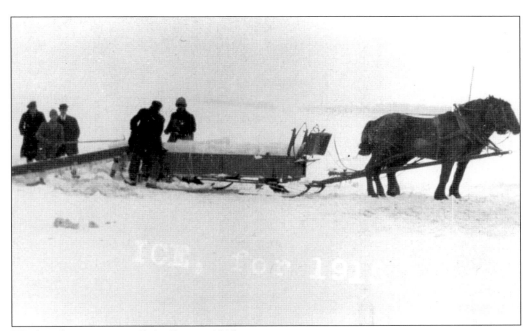

Workers harvest ice on Lake Erie in 1915.

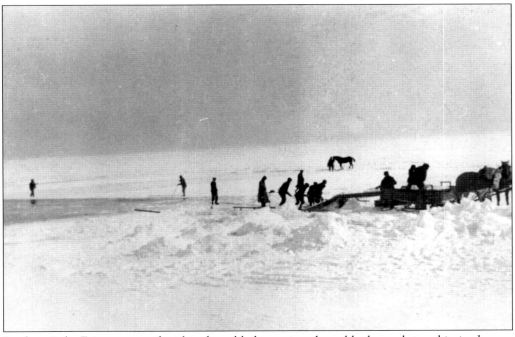

Ice from Lake Erie was scored with a sharp blade, cut into huge blocks, and stored in ice houses filled with sawdust for preservation. This picture was taken during ice cutting on January 15, 1915.

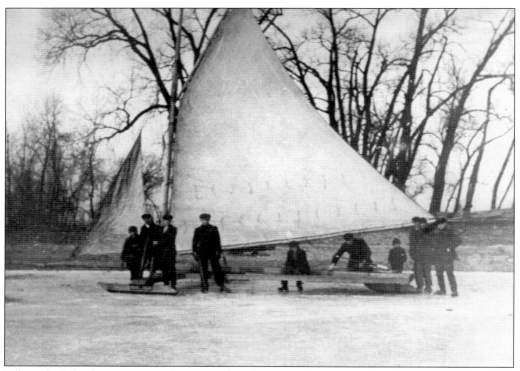

When the lake froze over, ice skating and ice boating were very popular in Fairport.

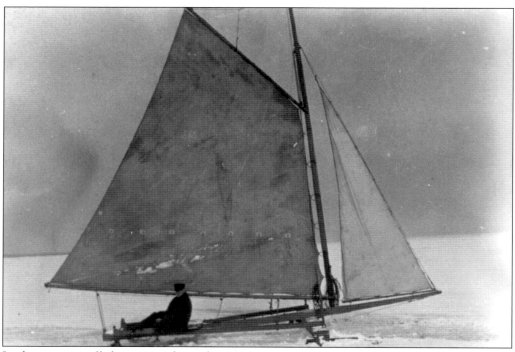

Ice boating was all the rage in the early 1900s.

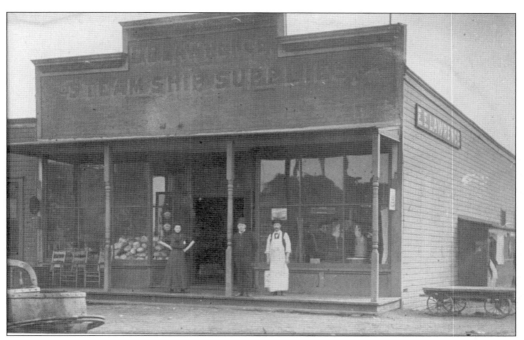

Posing here are Mary Farell, E.E. Lawrence, and Herbert Lawrence in apron. This store was located on Second and Water Streets. Notice the loaves of bread in the window.

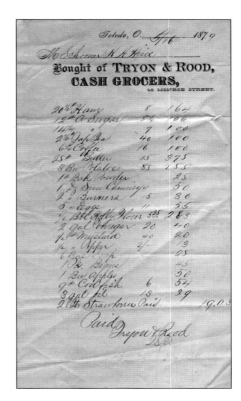

Here is the 1879 grocery and supplies list for the schooner H.H. *Hine*.

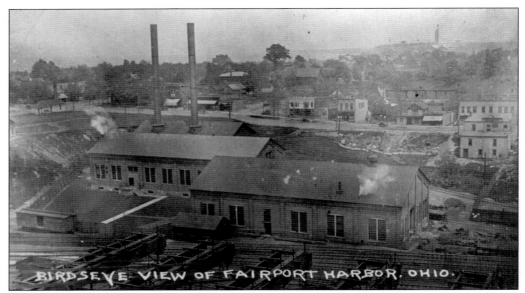

Many interesting details can be seen with a magnifying glass in this 1930 view of Fairport. In the foreground, parts of the Brown Hoists are visible. At the far left is the old village hall; across the street is the Arlington Hotel; to the right of the smokestack is the cupola of the Third Street School; the steeple of the Congregational Church can be seen under the large tree in the center. This is the only known photograph of the bridge (at far right) that crossed the gully on Eagle Street.

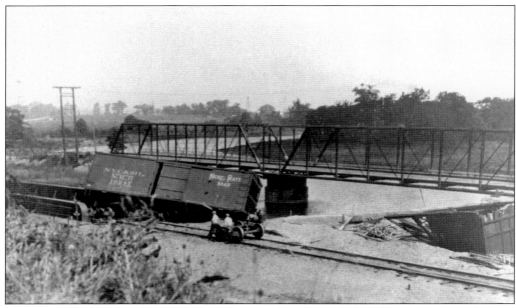

High Street bridges over Grand River in Fairport. Trucks on the tracks serve to assist derailed boxcars.

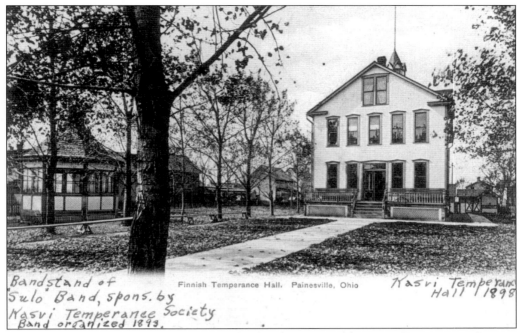

Pictured here is the bandstand of the "Sulo" band, sponsored by Kasvi Temperance Society. The band was organized in 1893. On the right is the Kasvi Temperance Hall, built in 1895.

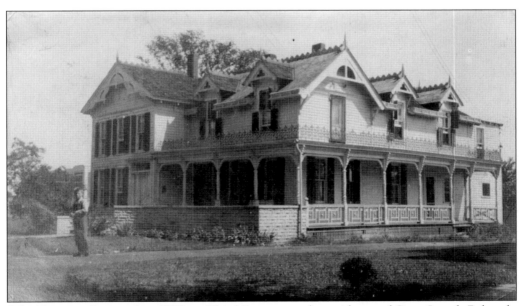

"The Fairmont," erected in 1878 on Third Street, was the residence of Capt. Joseph Babcock. The house still stands, though it is altered in appearance.

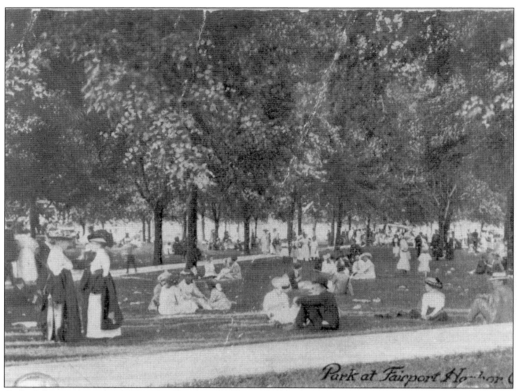

A Sunday outing occurs at the Fairport Village Park.

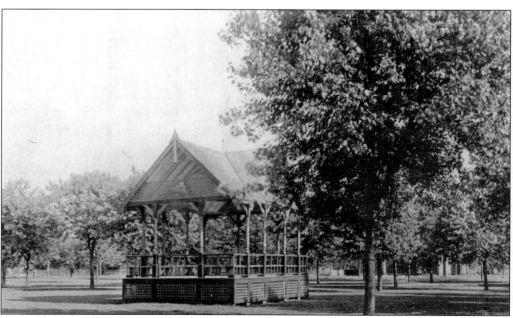

Pictured here is an old bandstand in Fairport Village Park.

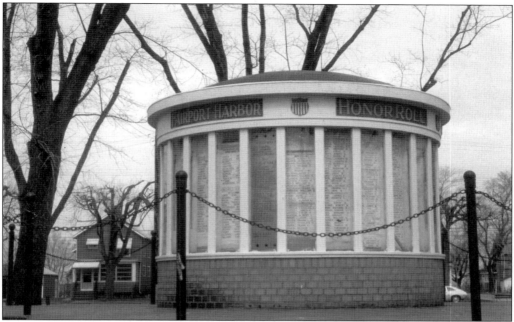

One of the finest monuments to war heroes in the state of Ohio stands in the center of Fairport Memorial Park. The Honor Roll, a beautiful circular memorial, is lighted in the evenings. It was built in 1944 and reconstructed in 2002. This photo was taken in 1975.

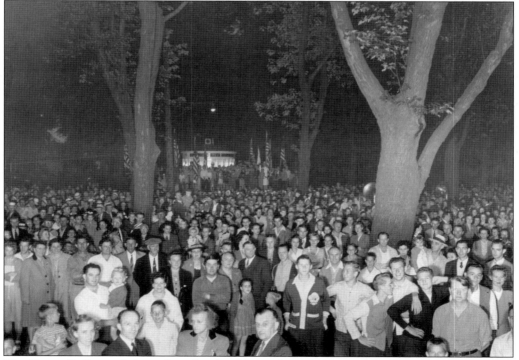

The Honor Roll was dedicated on Sunday, November 26, 1944.

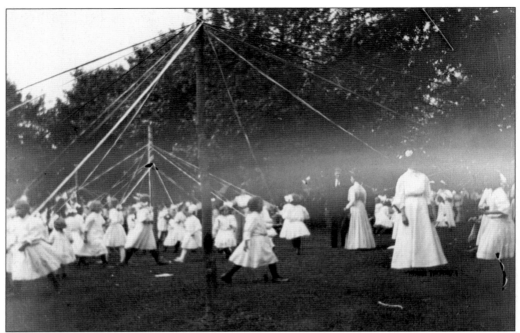

During the Pilgrim Celebration on June 23, 1909, a maypole dance was held in the park.

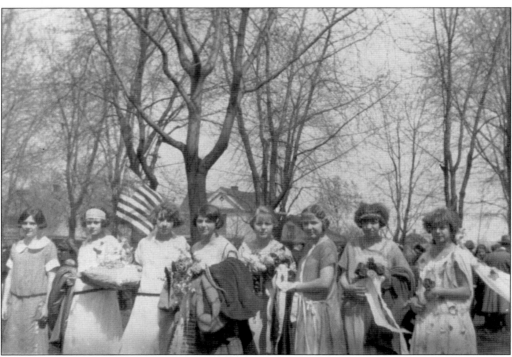

Pictured here at the 1924 May Day celebration are, from left to right: Alma O'Janpa Ollila; Helen Horacek Lynch; Marie Horacek Kohlerman; Mary Kovach Carmody; Jennie Ritari Patterson; Ruth Tuuri Isackila; Ruura Tuuri Baker; and Lillian Katila Lintala, Queen.

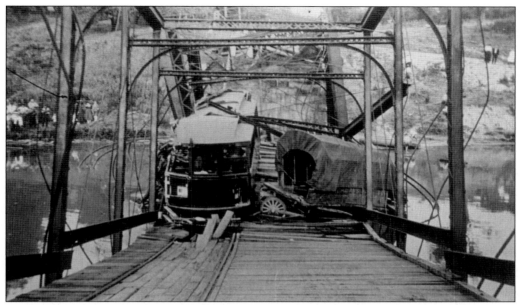

Pictured here is a trolley car on the St. Clair Street Bridge, which collapsed on August 7, 1918, at 1:10 p.m.

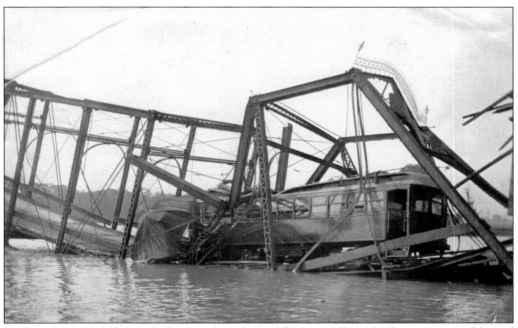

A car and a truck fell with the bridge when the middle span collapsed. The car was northbound and was in the act of passing the motor transport's trailer when the two collided. With the combined weight of the two, the shock caused the bridge (which was said to have been condemned for some time) to collapse. The trailer was drawn by two horses that succeeded in breaking loose and swimming ashore—one landed on one side of the river and other on the opposite side. Eight people were injured.

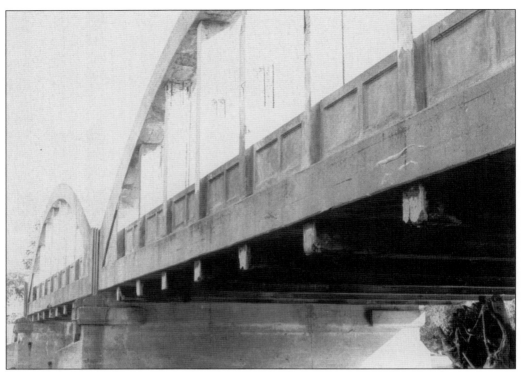

Pictured here is the beginning of demolition of the St. Clair Street Bridge in 1991.

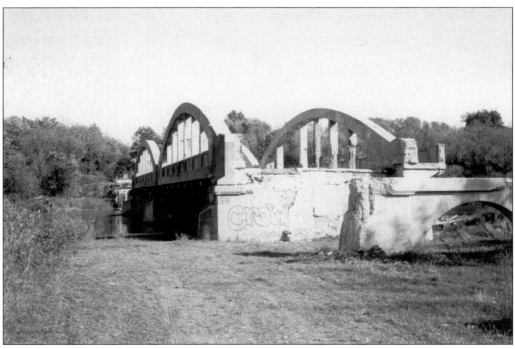

Demolition of the St. Clair Street Bridge begins in 1991.

Here is the christening of Columbia Transportation Company's *Frank E. Vigor* at Fairport, April 18, 1941. Pictured here, from left to right, are: Mrs. Frank E. Vigor; Mr. Frank E. Vigor, Mgr. of Transportation American Rolling Mills Co.; Mrs. Jane Vigor Gates; and Capt. David Huser. The *Vigor* collided with the *Philip Minch* in heavy fog on Lake Erie in 1944 and sank.

Captain Daniel Babcock is photographed in the village park during the ice storm on February 15, 1909.

This picture was taken from the backyard of Captain Daniel Babcock's home at 411 Third Street, looking toward the corner of Third and Plum Streets, during the ice storm of February 1909.

Pictured here is the home of Dr. M. Cadwell at 207 Eagle Street. The house still stands, though modified in appearance.

Here is a view of Second Street taken from the corner of Second and East Streets, *c.* 1920s. Houses on the north side belonged to John Tirpak family; the next house belonged to the John Pillar family; and the house in the background was occupied by the John Horacek family. It later became the cafeteria and recreation office of the Diamond Alkali Company. Trolley tracks ran down the center of Second Street.

This picture looks east on Second Street. Streetcar tracks were buried down the center of Second Street. The Horacek residence is at the far right.

THE LIGHTKEEPER WONDERS

The light I've tended for 40 years .
is now to be run by a set of gears.
The Keeper said, And it isn't nice
To be put ashore by a mere device.
Now, fair or foul the winds that blow
Or smooth or rough the sea below,
It is all the same. The ships at
night will run to an automatic light.

That clock and gear which truly turn
Are timed and set so the light shall burn.
But did ever an automatic thing
set plants about in early Spring?
And did ever a bit of wire and gear
A cry for help in the darkness hear?
Or welcome callers and show them through
The lighthouse rooms as I used to do?

'Tis not in malice these things I say
All men must bow to the newer way.
But it's strange for a lighthouse man like me
After forty years on shore to be.
And I wonder now—will the grass stay green?
Will the brass stay bright and the windows clean?
And will ever that automatic thing
Plant marigolds in early Spring?

<div style="text-align: right">Edgar Guest</div>